digital photographic capture

Bergen Watercolour #1. © Ian Macdonald-Smith.

DIGITAL PHOTOGRAPHIC CAPTURE

by

Glenn Rand

Brooks Institute of Photography

David Litschel

Brooks Institute of Photography

Robert Davis

Digital Directions

ELSEVIER

AMSTERDAM • BOSTON • HEIDELBERG • LONDON • NEW YORK • OXFORD • PARIS
SAN DIEGO • SAN FRANCISCO • SINGAPORE • SYDNEY • TOKYO

Focal Press is an imprint of Elsevier

Focal
Press

Acquisition Editor: Diane Heppner
Project Manager: Paul Gottehrer
Editorial Assistant: Becky Golden-Harrell
Marketing Manager: Tricia LaFauci
Cover Design: Cate Barr
Interior Design: Julio Esperas

Focal Press is an imprint of Elsevier
30 Corporate Drive, Suite 400, Burlington, MA 01803, USA
Linacre House, Jordan Hill, Oxford OX2 8DP, UK

∞ Recognizing the importance of preserving what has been written, Elsevier prints its books on acid-free paper whenever possible.

Library of Congress Cataloging-in-Publication Data
Application submitted

British Library Cataloguing-in-Publication Data
A catalogue record for this book is available from the British Library.

ISBN: 0-240-80632-8

For information on all Focal Press publications
visit our website at www.books.elsevier.com

04 05 06 07 08 09 10 9 8 7 6 5 4 3 2 1

Printed in China

For Marguerite

contents

acknowledgments

On the way to this book we had assistance from many people and wish to thanks them. First were those closest to us, our wives Sally, Martha, and Peggy. Next, this project could not have happened without the wonderful guidance of Diane Heppner, Paul Gottehrer and the staff of Focal Press.

The book was enabled by the input from the reviewers Trudy Baker-Tate, Ryan Baldwin, Ike Lea, Richard Zakia, and Gordon Brown. We also received support from Scott Miles, Christopher Broughton, and Russ McConnell who helped with their workflows. There were also the many artists who have graciously allowed us to use their images and they are listed at the end of the text. We also received support from numerous corners of Brooks Institute of Photography, particularly many students in the graduate program.

Manufacturers were also helpful in putting together this book. Ruben Dario Cruz, Tameron, USA Inc.; Jim Davis, Eastman Kodak Company; Canon, U.S.A.; Mamiya America Corporation; Nikon, USA; and Phase One provided information and/or illustrations for the book.

We hope that this book will help you in your journey through digital image capture.

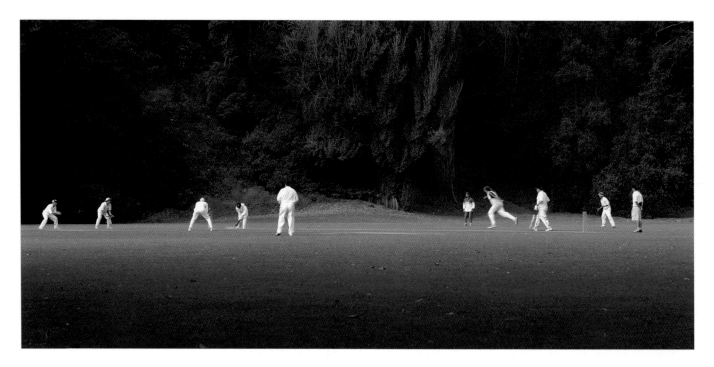

Nelson Cricket Match. © Russ McConnell.

introduction

Two major issues became clear as we undertook the production of this book. First is that making images is the prime conscience act of digital photography and second is the speed of technological change that will impact our capture tools.

Most important is making digital photographs . . . taking pictures. This encompasses the eye-mind combination working to define what will be seen in the final image. There must be an underlying desire on the part of the photographer to make images. This drives the process and the choice and use of tools.

It is important how you start the process. The primary activity of a photographer is recording the original image. This has been the role of the photographer since the beginning of photography. While computers can do many things, they cannot make photographs. Regardless the robustness of the software, it needs base images to work with and the photographer's ability is first found in how they conceptualize, find, compose, and capture that image. If the photographer starts with a poorly captured image there will be little expectation of making a great image regardless of the sophistication of the computer or manipulation software. For the capture devices, software, computer, and printers are just tools. Tools in the hands of an artist can help make art but alone the tools cannot.

The second point is the speed of the technological change while putting this book together. This is the nature of the world of digital imaging. The abilities of

cameras and digital imaging systems are changing rapidly and the rate of change is also accelerating.

This raises two problems for writing a book in this changing environment. First, any products that are shown will become older technology soon and it dates the book. Most books tend toward historical views since they put down with ink on paper what the author(s) know at the time of the writing. Second, this forces us to approach the technology in a more general manner because these will be the constants as the technology improves. We are trying to present basic technologies and concepts that relate to digital capture and not try to present a manual on how to use the most current specific camera or system.

There are many facets to the creation of digital images beyond its capture. While their use in imaging software and the opportunities that these provide, there are various texts on the latest software. The concept of the book is to explain the basic technology and ideas used in the acquisition of images used in today's vast digital imaging world.

Each chapter has an overview, summary, and callouts for terminology. A brief overview begins each chapter and indicates the major points being discussed in the text. At the end of each chapter is a bulleted summary. Because the knowledge base for the materials in the body of the book may be new to some readers, as we progress through the book we have pulled out terms and ideas important to understanding basic concepts of digital capture. These ideas and terms will be part of a brief glossary at the end of each chapter with the total indexed glossary following the body of the text.

The images are as important as the text in this book. The images presented in the book are intended to both display ideas spoken about in the text and to show exciting visual concepts used in today's digital imaging. We have tried to assemble photographs that do more than simply utilized the technology. It is our intent to show images that can inspire. The work shown in the book has been acquired from

many photographers to give a wide view of the capabilities and applications of this technology. While some of the images will rely on manipulations of images common today, the book is about how images are captured and not how they are manipulated.

We hope this book will help you in your journey through digital image capture,

Glenn Rand
January 2005

about the authors

Glenn Rand received his Bachelor and Master of Arts from Purdue University with a Doctorate from the University of Cincinnati. He did post-doctoral research as a Visiting Scholar at the University of Michigan. Photographs by Dr. Rand are in the collections of over 20 museums in the United States, Europe, and Japan and is exhibited widely. He has also published his photographs as both editorial illustrations and advertising. He has published and lectured extensively about photography and digital imaging ranging from commercial aesthetics to the technical fine points of black and white photography. His consultant clients have included the Eastman Kodak Company, Ford Motor Company, Photo Marketing Association International, the Ministry of Education of Finland, as well as many other businesses and several colleges. Presently Dr. Rand teaches in the graduate program at Brooks Institute of Photography in Santa Barbara, California.

David Litschel is a noted educator, photographer, author, and consultant to industry and education. He is the Provost at Brooks Institute of Photography with campuses in Santa Barbara and Ventura, California. Prior to taking on his current administrative role, he was a faculty member at Brooks Institute of Photography for over 15 years. He has been active in many professional organizations, including serving as President and a member of the Board of Directors of the Photo Imaging

Education Association (PIEA). He previously co-authored a college textbook on photography now in its second edition that is used by schools in all 50 states, Canada, England, Australia, and has been translated into Korean. Mr. Litschel is a member of the Advisory Board for *Photographer's Forum* magazine, and has served on the Board of Directors of PhotoAccess.com, in Seattle, WA. He received his MFA from the University of Michigan and his BFA with Phi Beta Kappa from the University of Colorado at Boulder.

Dr. Robert Davis was the first Digital Technical Sales representative for the Eastman Kodak Company. In his role at Kodak he was involved in the marketing of digital products. Since leaving Kodak he has been involved in various educational endeavors including teaching digital imaging to the FBI and other law enforcement agencies. He has also set up educational programs at community colleges and has been a lecturer in the field.

Olysuit_w1. © 2004 Douglas Dubler

why digital?

Chapter 1 Overview

This chapter addresses why we want to capture digital images and discusses several of the advantages offered by new digital capture technology.

The Evolution of Photographic Processes

To begin, we might ask, "Why is the photographic industry changing to digital imaging?" First, though, let us consider how this technology has evolved. History has shown us that when a new technology emerges we can expect resistance from providers of established technologies who are concerned about their products being displaced. In this case, digital imaging technology is the new technology, and **silver halide photography** is the older one. Advocates for a technology already in place tend to put up an energetic defense of the economic and social status that has been gained by the existing technology over time and will argue against adoption of the new innovation. For this reason, we will examine here the struggle for supremacy that is currently taking place between **digital imaging** and film-based photography.

Silver halide photography Method used for film-based photography (both color and black and white) that utilizes silver halide crystals as the light-capturing element.

Digital imaging Using digital computing devices and processes for producing photographs.

This struggle for position is a difficult one that will result in a winner and a loser—no ties allowed. One competitor will become the dominant technology, and the other will have to adapt or disappear altogether. In looking at the histories of technological changes, we can see that the newer technologies always win the battle to eventually displace the older ones. Today, we are witnessing the final battle of digital versus film-based photography, and it is clear that digital imaging will come out on top and that the role of film within photography will change.

How quickly we switch to a newer technology is influenced by its rate of development. Like other innovations made possible by developments in microcircuitry, digital imaging has evolved rapidly. Gordon Moore, CEO Emeritus of Intel, said that computing power doubles every year and a half, while the cost of the technology stays the same. Digital imaging is dependent on microcircuits, and "Moore's law" applies. We have witnessed rapid improvements in the size and image-gathering abilities of digital sensors, in the functions that are facilitated by digital imaging technology, and in the changes in workflow resulting from the new technologies. Within this changing environment, several change agents have been at work, accelerating the adoption of digital imaging technologies. The following discussion does not provide an exhaustive list of all the factors affecting adoption of digital imaging technologies, but it does highlight the most significant ones.

The development of computers not only provided the technology for digital imaging but also created new and intensive applications of these images. Development of the World Wide Web and digital prepress software, for example, has made it easier to incorporate images in areas of communication where they previously could not have been included. The portability of images is an important factor that has had a significant effect throughout the imaging world, as images in digital form can travel on any carrier that can carry digital data.

A digital image can be manipulated in myriad ways by a wide variety of digital tools, a feature that is especially important in the field of publishing. Digital pho-

Miller 59316 C2 Composite. Jon Miller © Hedrich-Blessing 2002.

tography has allowed photojournalists to provide almost instantaneous images for immediate use anywhere in the world. It has also allowed photographers in the field to work more closely with editors and art directors back in the office; for example, an art director can approve a layout before the photographer shoots the final exposure. The digital format has also provided more consistent and accurate reproduction of images in printed materials.

From an image processing perspective, the production of digital images is simpler than film processing and production. In the silver halide photographic system, a series of chemically complex steps is required before the final print is obtained, whereas with digital imaging a print can be produced directly from the camera. When corrections are required, they are less time consuming for digital images than those produced from film. Moreover, the printing of digital halftones is more efficient and provides results that are closer to the original image and less cumbersome to obtain.

For many, the ability to manipulate an image is the greatest reason for using pictures in a digital format. Numerous software packages offer the ability to alter many aspects of an image to obtain a particular effect with far less effort than is required for images produced by traditional film-based methods.

It is no longer a question of *if* digital capture will become the major photographic capture process; that will come to pass in the near future. Since the photographic process was first used in 1839, there been a constant march toward development of a more convenient picture-making method. Photography evolved from the dangerous and slow **daguerreotype** to the modern **Polaroid® dye migration process**. Negative processes could be duplicated, but the direct processes were not convenient for making duplicates or prints.

The **charge-coupled device (CCD)** was developed at the Bell Labs in 1969, which began to make its mark in imaging in the 1970s. At the same time, the commercial world began to make great advances in the area of **color electronic prepress**

Daguerreotype The first successful photographic process, introduced in 1839, in which an image is exposed directly onto a highly polished silver plate; the image is developed using a vapor of mercury that condenses on the plate to form an amalgam producing an image.

Polaroid® dye migration process Process in which dyes that form the print migrate from within the processing film to create an image on the print surface (i.e., "instant print").

Charge-coupled device (CCD) An electronic device made up of light-sensitive sites arranged to process the output in a linear process. The charges recorded and output from each site are proportional to the light intensity at each site.

Color electronic prepress system (CEPS) or digital prepress The process of using computers or other electronic equipment to prepare plates for the printing press.

systems (CEPS). Electronic imaging was used for television and scientific imaging for many years before it was applied to the field of commercial still photography, because for quite some time the resolution of still video was not acceptable and could not compete with film—at least not until the introduction of the Sony® Mavica™. By the end of the 1980s, low-cost personal computers were commonplace, a variety of imaging software had been released, and a new generation of printers and cameras was readily available, all of which led the way toward a new era of digital photography.

The complementary metal oxide semiconductor (CMOS) was developed in 1963, but it was not until the 1990s that it was repurposed for use as an imaging sensor in cameras. Initially, the use of electronic still imaging (digital capture and scanned images) was limited to scientific and governmental/military applications, which took advantage of the portability of digital images, the ability to record spectral areas beyond film, and the short acquisition times.

Fine artists were also early adopters of digital imaging. It was not uncommon for artists to use stills from video cameras and copy machines as image sources to be incorporated in their work. While these were generally low-quality images, they allowed artists to experiment and move in new directions.

Early uses of digital images in professional photography occurred primarily in the realm of photojournalism, and by the early 1990s some newspapers had closed down their darkrooms entirely. Because newsprint is highly absorbent, images cannot be printed in as fine a detail as on other paper stocks; thus, the somewhat lesser quality of digital images at the time was not a factor for newspaper production. Also, newspapers have always had a need for timely images, and the digital transmission of images offered them a method for acquiring and placing images rapidly. In 1988, Leaf Systems introduced Leafax™, a portable electronic device that included a scanner and allowed photojournalists to send their images around the world; it quickly became an essential component of the photojournalist's arsenal.

Sink. © Ralph Masullo.

As the digital technology continued to improve, more areas of photography began to accept the use of digital imaging. The introduction of Photoshop® increased the interest in digital imaging and remains important in the field today. Digital cameras and scanners at lower prices but of higher quality essentially guarantee that the film-based photographic process that has matured over the last 165 years will eventually disappear. The greatest growth in digital photography today is occurring in the amateur photographer market, while commercial applications of digital photography are also expanding.

In 2004, more fixed-lens digital camera devices were manufactured than conventional fixed-lens film cameras. Single-use digital cameras are growing in popularity, and the variety of e-mail images, digital minilabs, and desktop output devices are having an effect on the digital market. The addition of digital photography technology to mobile phones is yet another important development.

Before imaging software can work its magic, we must have an image, and having an image in a digital format opens up unlimited possibilities. It would be nice to know where digital imaging will take us in the near future, but, to paraphrase Yogi Berra, "It is risky to make predictions, particularly about the future." There are, however, several things we can say about the future with some certainty. First, we can expect that digital technology will continue to evolve, although it is difficult to predict exactly the results of these inevitable changes. Next, we can be sure that these changes will be rapid. Finally, we need to be flexible enough to adopt these innovations and put them to use in our everyday lives.

Summary

- Digital imaging is a new technology will displace the old—silver halide (film-based)—photography.

Pirenhurst. © James Chen, Santa Barbara.

- Several innovations have encouraged the switch to digital imaging. These include the portability of images, the wide range of applications, and the availability of software to manipulate the images.
- Digital imaging has become a major source of input for many applications throughout all phases of photography.
- Digital imaging has established itself as the major commercial method for producing images and will soon become the same for the consumer.
- New developments in imaging technology will increase into the foreseeable future at a rapid rate.

Glossary of Terms

Charge-coupled device (CCD) An electronic device made up of light-sensitive sites arranged to process the output in a linear process. The charges recorded and output from each site are proportional to the light intensity at each site.

Color electronic prepress system (CEPS) or digital prepress The process of using computers or other electronic equipment to prepare plates for the printing press.

Daguerreotype The first successful photographic process, introduced in 1839, in which an image is exposed directly onto a highly polished silver plate; the image is developed using a vapor of mercury that condenses on the plate forming an amalgam producing an image.

Digital imaging Using digital computing devices and processes for producing photographs.

Polaroid® dye migration process Process in which dyes that form the print migrate from within the processing film to create an image on the print surface (i.e., "instant print").

Silver halide photography Method used for film-based photography (both color and black and white) that utilizes silver halide crystals as the light-capturing element.

Ann's Braid Case. © J. Seeley.

capture devices

Chapter 2 Overview

This chapter looks at methods used to capture digital images and how these pictures are used. We begin with a discussion of the basics of the camera and the types of cameras that are used in digital capture. There are three basic ways to acquire an image in the digital environment. The most direct is the use of a camera; however, images can also be acquired by scanning already existing print or film images, and images can also be taken from resident computer-based images. Regardless of the source, the image will be in the form of numbers and will be applied to its final use through electronic output.

Camera Basics

Cameras have been used to make images since the 15th century, thus predating photography by 400 years. In the earliest application of camera technology, an artist used a **camera obscura** to assist them in their art. When the ability to record the light as it passes through the camera was developed in the first half of the 19th century, the

Camera obscura The term *camera obscura* is Latin for "darkened room." The original camera obscura was a darkened room with a hole at one end. An image would be projected through this small hole onto the opposite wall. The image would be inverted. The camera obscura evolved into smaller darkened boxes that used lenses, mirrors, and/or ground glass to aid artists and early photographers.

way in which we looked at pictures and their uses changed, and we accepted that a picture was able to capture reality. Today, we are at another transition point in the use of cameras. While, in 1839, Daguerre and Talbot showed how to capture light with silver, now we are using electronics to accomplish the same end.

The basic structure of the camera has not changed since its development those many years ago. The name *camera obscura* is Latin for "darkened room." The major improvement to the camera obscura of the 15th century was the addition of a lens to brighten and focus the image. Beyond the use of a lens to project light onto a receiving surface, the camera has changed little from the original darkened room that had one opening to allow an image to be formed. Today, a lens focuses the light from the scene being photographed and allows a larger amount of light into the darkened chamber.

Digital cameras are the same as all other cameras in construction and basic optics. The major difference lies in the fact that digital cameras use an electronic sensor to capture the light, whereas an artist's pencil or photographer's film was used in previous cameras. Most people define cameras by their viewing structure and film size. Digital cameras use no film but still have a viewing system as part of the structure of the cameras. Cameras used to capture digital images can best be defined as "**point-and-shoot**," viewfinder, **single-lens reflex (SLR)**, view, and computer-aided viewing systems.

"Point-and-shoot" cameras are what they sound like. These are as simple as the small cameras that are placed on top of a computer monitor. This camera is pointed toward a specific place and whatever is in that area or whatever moves into that area will be captured. This definition is also applied to smaller cameras that have few controls. Although cameras with only a **liquid-crystal display (LCD)** can be said to have a viewing system, these cameras are often also considered point-and-shoot. A professional camera of somewhat similar design as the amateur point-and-shoot is the rangefinder camera. While a traditional rangefinder camera uses an optical ranging

Point-and-shoot An amateur camera that is simple to use.

Single-lens reflex (SLR) A camera viewing system that uses a mirror at a 45° angle in front of a sensor that projects the image onto a ground glass, thus allowing direct viewing of the image that will be captured.

Liquid-crystal display (LCD) A display technology often used on digital camera backs and computer monitors.

Yellow Flower on a Sunny West Texas Day. © 2003 Steve Lama.

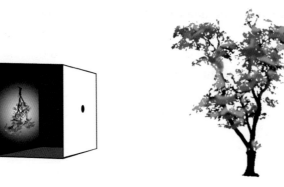

Figure 2-1 The word *camera obscura* means "darkened chamber." Light passing through a hole on one side of a structure projects an image on the opposite surface. A lens can be used to increase the effectiveness of the projection of the image.

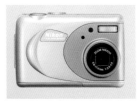

Figure 2-2 The most common digital cameras sold are amateur cameras known as "point-and-shoot." (Courtesy of Nikon, USA.)

device, the digital camera can easily back this up with the autofocusing capabilities inherent with digital sensors. Today, mobile telephones have capture devices that function as point-and-shoot cameras. These telephone cameras can create pictures of reasonable quality for very small prints (5 × 7 inches). While the sophistication and sensor size of these telephone cameras are improving, there is the issue of being able to make prints other than online. Also, sensor devices have been designed for and can be attached to a personal digital assistant (PDA) to allow it to capture pictures.

The *viewfinder camera* has an optical viewing system that is parallel to the imaging optic. While the viewing system is not connected to the focusing of the imaging optic, it allows viewing the scene for framing. If the camera has a zoom lens, the viewfinder changes its focal length as the zoom lens moves. If the viewing system is connected to a focusing system to allow the camera to be focused independently, then the camera is considered a rangefinder camera.

The *single-lens reflex (SLR)* camera has long been the mainstay for both amateurs and professionals. This viewing system uses a mirror at a 45° angle at the back

of the camera to project the image onto a ground glass. This allows the photographer to see the image exactly as it will be focused and projected on the sensor. In 35-mm cameras and some medium-format SLRs, **pentaprisms** allow the image to be viewed through the mirror without any reversal of the image by the lens. These cameras also have LCD displays, but they are not as convenient for use as a compositional or focusing tool. The LCD on the SLR camera is primarily for proofing and monitoring various functions, such as white balance, settings, and formatting.

The last type of camera commonly used for digital capture is the *view camera*, which is the simplest of the cameras in concept but is versatile because of the ability to reposition the camera's parts to accomplish perspective control and specific image corrections and distortions. These cameras are larger and often use camera backs to capture images digitally. A common variation of the view camera format is to permanently attach a digital capture device to the back in place of the ground glass. A computer is then used to view the image instead of getting under a dark cloth to view the image projected on the ground glass.

Pentaprisms In single-lens reflex (SLR) cameras (both 35-mm and some medium format), pentaprisms allow an image to be viewed through the lens and reflected by a mirror without any reversal of the image.

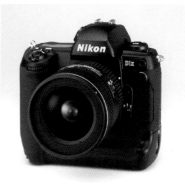

Figure 2-3 Single-lens reflex (SLR) digital camera. (Courtesy of Nikon, USA.)

Digital Cameras

In today's marketplace, there are three levels of cameras along with digital camera backs. These are defined by the sophistication of the applications, not by any lack of technology; while there are differences in what each level can provide, all the cameras are high-level electronic devices. The cameras are roughly classified as consumer, **prosumer**, and professional. Consumer cameras range from capture devices that can sit on top of a computer monitor to what we might consider a small point-and-shoot film camera if we did not know how it was capturing the image. A camera that is used to quickly record pictures and snapshots is considered to be a "consumer"

Prosumer A blend of "professional" and "consumer," this term is used to refer to systems that include many professional functions and are intended for use by advanced consumers.

camera. While these cameras feature high-level technology, they are not as flexible in taking pictures as higher-level cameras. Most consumer cameras are of the viewfinder design and/or use LCD framing. These cameras come with a dazzling array of options. All of these are made possible because of the onboard computing power of their microprocessors. It is not uncommon for a consumer camera to have more than three dozen options. Photographers using a consumer-level camera, however, should take several factors into account. First, consumer cameras normally have a limited ability to take a number of pictures in quick succession. Also, because of the way these cameras prepare to take pictures, a pronounced lag time can occur between when the button is depressed and when the camera actually takes the picture. While very convenient to use, consumer cameras tend to limit the photographer's control over the photographic process, as options such as focus, light variation, and connection to lighting equipment are not available. In addition to a lack of control, the consumer-level cameras do not allow photographers to save or export as many file types as they might with more advanced cameras. Also, not as much information is available for the photographer to use because of the preset algorithms used in these cameras.

In the area between consumer-level cameras and professional cameras are the "prosumer" cameras, which are defined as cameras that have many of the features and abilities of a professional model while being priced more toward the consumer camera level. These cameras are intended for use by serious amateurs and professionals who do not need all of the abilities of professional models. For many photographers, this level of camera addresses all their needs.

As we move to formats that have more applications within the professional realm, it is important to be aware of the time needed to capture an image; for example, some cameras capture the image at one instant and others acquire images over time in different ways. Generally, cameras and camera backs can be divided into three types: single capture, tricolor photography, and scanning. While single capture allows for simultaneous **tricolor** capture, the other two methods take more time. This means

Red Egg Chair. © Gabe Hopkins.

that only single capture can be used for moving subjects to eliminate the possibility of color or movement effects in the image. These distinctions to some extent also relate to image quality and file size. For many images, tricolor or scanning capture gives more accurate color because no interpolation is required to generate the color (this topic will be discussed in greater detail in Chapter 5). Also, because of the way scanning backs work, they can produce very large image files.

In addition to having bigger sensors and being more costly, professional cameras are designed with specific applications in mind. They have different architectures for their chips, faster response times, and multiple frame capabilities. They can write files in many formats, with or without **compression**. Many offer the ability to use accessory lenses and lighting equipment.

Many professionals choose not to have a camera that is designed only for digital capture and instead use digital backs. A digital back is a sensor and support microcircuitry that attach to the back of an existing film camera. The digital back replaces either the film plane or film back. The four types of backs are area arrays and scanning backs using either **tricolor (three-shot) photography** or integrated three-color filtration at the sensor sites. Further, some digital backs are cooled. A cooled back utilizes a fan or other cooling method to reduce the temperature of the sensor sensor's surface. This cooling reduces the noise present in the captured image.

The difference between the various backs is the way in which the image and colors are captured. With an area array, the image capture is instantaneous. With a scanning back, a linear array is passed through the light pattern for capture. A line or set of sensors moves across (scanning) the imaging area, capturing the image in sequenced, stepped exposures. For both area and linear configurations, the color can be captured in one process step using filters over the sensor sites or through three successive exposures through filtration on the camera or over the sensor.

Compression A method to reduce a file size by performing mathematical operations on the data file.

Tricolor photography Tricolor or trichromatic systems are three-shot capture methods in cameras or scanners that utilize three colors of light (red, green, and blue).

Untitled. © Lawrence Anderson.

Figure 2-4 and Figure 2-5 Digital backs can be either single capture area arrays or scanning backs using stepped linear arrays. (Both figures courtesy of MAC Group.)

Figure 2-6 A problem with photographing moving subjects with a scanning back is that the stepping and scanning functions can break up part of the image that is in motion.

Trilinear arrays Sensors that use three-color filtered arrays over three parallel linear sensors. The simplest configuration has one line each of red, green, and blue filtered sensors.

Many backs must be connected to a computer during operation. This is known as *tethering*. The connection to the computer device allows the photographer to take digital proofs and in many cases control the exposure through the computer. In some cases, this allows for multiple exposure adjustments and controls. While it might seem that tethering requires the camera to be used only in studios, both laptop computers and PDA devices allow these capture devices to be used on location.

Scanners and More

Scanners allow artists and photographers to use existing prints or negatives to acquire digital images. These scanners are primarily film or flatbed. While it is possible to use some flatbed scanners to acquire images from film, doing so tends to be unsatisfactory for 35-mm film. Flatbed scanners use **trilinear (three-color filtered) sensors**, but film scanners use area arrays, linear three-color imaging, and trilinear arrays. For some scanners, software allows the elimination of surface flaws in or on the film that might

Toshiba Personal. © Tom Seawell, Seawell Photography,
San Francisco, CA.

Figure 2-7 and Figure 2-8 Flatbed scanners use linear sensors that pass across the original document, while film scanners use all forms of sensors (linear, trilinear, and area arrays). Courtesy of Canon U.S.A. (Figure 2–7 is courtesy of Canon, USA. Figure 2-8 is courtesy is Nikon, USA.)

interfere with capturing a clean image. Cameras, backs, and scanners make up the vast majority of equipment used to produce images in a digital form, but other methods also allow photographers to obtain images. Perhaps the most accessible method is appropriating images from the World Wide Web; however, one caveat with regard to "lifting" images from the Web is that copyright laws protect many of the images, and local or national laws may restrict use of these images. Digital images are also created by some types of scientific equipment, ranging in scope from electronic microscopes to astronomical imagers. While these images are intended for specific scientific applications, they can also be used in personal or commercial artwork.

Summary

- The camera is not a new tool and works the same with digital capture.

- **Various types of** digital cameras are manufactured for different photographer using cameras from "point-and-shoot" to advanced professional systems.

- Digital backs are used with film-based cameras to allow them to capture digital images directly.

- Scanners are used to create digital images from prints and film; other methods of acquiring images include downloading images from the World Wide Web as well as obtaining images from other digital systems.

- Digital imaging has moved its way into and become a major input for many applications throughout all phases of photography.

Glossary of Terms

Camera obscura The term *camera obscura* is Latin for "darkened room." The original camera obscura was a darkened room with a hole at one end. An image would be projected through this small hole onto the opposite wall. The image would be inverted. The camera obscura evolved into smaller darkened boxes that used lenses, mirrors, and/or ground glass to aid artists and early photographers.

Compression A method to reduce a file size by performing mathematical operations on the data file.

Liquid-crystal display (LCD) A display technology often used on digital camera backs and computer monitors.

Pentaprisms In single-lens reflex (SLR) cameras (both 35-mm and some medium format), pentaprisms allow an image to be viewed through the lens and reflected by a mirror without any reversal of the image.

Point-and-shoot An amateur camera that is simple to use.

Prosumer A blend of "professional" and "consumer," this term is used to refer to systems that include many professional functions and are intended for use by advanced consumers.

Single-lens reflex (SLR) A camera viewing system that uses a mirror at a 45° angle in front of a sensor that projects the image onto a ground glass, thus allowing direct viewing of the image that will be captured.

Tricolor photography Tricolor or trichromatic systems are three-shot capture methods in cameras or scanners that utilize three colors of light (red, green, and blue).

Trilinear arrays Sensors that use three-color filtered arrays over three parallel linear sensors. The simplest configuration has one line each of red, green, and blue filtered sensors.

Australian Coast. © Kathryn Watts-Martinez.

Chapter 3 Overview

The sensor is the key to digital capture. This chapter discusses how sensors are constructed and the basics of how they are designed to capture light and color. Within this chapter are considerations of types of metallic oxide semiconductors (MOS), the parts and functions of the sensors, and the architecture used for transferring the signal from the sensor. How the sensors function, how they are manufactured, and the limiting factors of the design of various sensors determine the success of the process.

Types of Sensors

Sensors commonly used in digital capture **are metal oxide semiconductors (MOS).** This name indicates that the basic elements for construction of the sensors are metal oxides, such as silicon oxide. The term *semiconductor* refers to the way the electronics function within the sensor. The two primary sensor types used in digital capture are the **charge-coupled device (CCD)** and the **complementary metal oxide**

Metal oxide semiconductor (MOS) A family of semiconductors constructed of metal oxides (such as silicon oxides) that are used to construct digital imaging sensors.

Charge-coupled device (CCD) An electronic device made up of light-sensitive sites arranged to process the output in a linear process. The charges recorded and output from each site are proportional to the light intensity at each site.

Complementary metal oxide semiconductor (CMOS) Computer chips that can be repurposed to act as a sensor. Because they are not specifically a sensor, as in the case of the CCD chip, they can handle many functions of the digital photographic process beyond capturing the light.

Photodiode The portion of a sensor that actually accepts the light, this is a construction of positive and negative portions (*di*, meaning two) that allow the light to be captured. These are also called *sites*.

Site The basic unit of the sensor; it is also called a photosite, photodetector, or pixel.

Electromagnetic spectrum (EMS) Range of energy, from long-wavelength radiowaves to extremely short gamma rays, including human observable light. Digital imaging sensors are capable of capturing the visible light and a portion of the infrared energy.

Gate Acts as a control in a digital imaging sensor that allows electrical charge or light energy to have an effect on the operation of the photosite. The gate both allows energy to enter the photodiode and restricts energy flow.

Depletion layer Region between the positive and negative semiconductors of the photodiode. This area is free of electrons or positive "holes." Without free or exposed charges, this region is considered depleted.

Doping Treating the photosite with an impurity. The dopant causes positive "holes" to be formed that allow the photodiode to collect light.

Indium tin oxide (ITO) A material often used in place of silicon to produce the gates of sensors. ITO tends to provide a better color range because it is optically more transparent than polysilicon.

semiconductor (CMOS). Both are metal oxide semiconductors. While the CCD is purely a sensor, the CMOS is a computer chip that can have other uses beyond its function as a sensor. Because the CMOS is more versatile and offers economies of manufacture, it tends to be less costly than CCDs for comparably sized sensors.

Regardless of the type of sensor, the basic unit is the **photodiode**. The photodiode (site or pixel) (Later) is comprised of layers of silicon, indium, or other metallic compounds that have been etched and assembled to absorb energy. Because visible light is the major source of this energy, the sensors correspond well with human vision. The sensor captures the energy in proportion to the amount of light reaching the sensor's surface. (Later)

When considering the photodiode, it is important to understand the scale involved. Typically, the sensitive area of a site used in many digital capture devices is less than 4 μm (1 micrometer = 10^{-6} m). Silver halide crystals are about 1 μm, or about one-quarter the size of common photodiodes. The photodiode has three primary parts: the **gate**, doped oxide layer, **depletion layer**, and well. **Doping** adds a foreign material (a dopant) to the surface that forms positive "holes" that allow the sensor to collect light.

While the gate can be viewed as the opening for accepting light, it is not always used for entry of the light. In some astronomical sensors, the rear side of the silicon is acid-etched to accept light through that surface. For the sensors used in digital photographic cameras, however, the gate is the access for the light to activate the site. **Gates** account for only a small amount of the surface or cross section of the sensor. Silicon is often used for the gates, but some are made of more expensive **indium tin oxide (ITO)** to provide capture across a greater color range. The ability of the sensor to accept light through a gate is increased by doping. Doping of the sensor sandwich

LSU Theater. © Chipper Hatter.

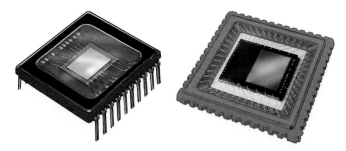

Figure 3-1 and Figure 3-2 In the charge-coupled device (CCD), both the connection pins and the wires from the surface of the sensor give an indication of the linear electronic function of the chip. With the CMOS, connections **around** the chip surface and **the** dark portion that contains active transistors that are not able to acquire light show the more complexity of chip functions **of the CMOS.**

Photons Electromagnetic energy functions in either a wavelength or particle function, and the "photon" is the designation used when the electromagnetic energy is acting as a particle.

Potential well Forms in the silicon base of the sensor when an electrical charge is applied to the photodiode. As the photons of the light are captured, a potential barrier is created that holds the captured energy until it can be discharged.

allows **photons** of light with specific energies to be captured. The part of the photodiode that absorbs the light energy is the **potential well.**

To understand how light is captured, we need to look at the functions and sequencing of the parts and processes used by the sensor. In order to make the process work, the sensor site must be prepared by positively charging all the gates on the sensor. The charging is done for two reasons. First, by applying an equal charge on all gates, a uniform background is created that can be used to measure the changed charge values created by the photons that strike the sensor. The other reason is that photons act as negatively charged particles and, because opposites attract, the positive charge creates the sensitivity required to **make an** exposure. Because the site is grounded by the potential well, the charge on the gates migrates through the depletion layer to the wells, giving all sites on the sensor the same charges on their wells. Even though the charge has migrated to the well, its charge value is still effective in the capture process. At this point, the site can capture the light energy striking any gate.

Figure 3-3 Cross section of a photodiode shows the basic parts.

The photons of light are not electrons but they function as negative energy when striking the sensor's gates. Because the wells now have positive charges, the negative energy created by the light striking the gate is attracted to and captured in the wells. This process continues until the wells reach their maximum capacity. When the negative charge reaches excess capacity at a site, it will migrate to nearby sites. This effect is known as "**blooming**"; however, most cameras today are manufactured with **anti-blooming technology**. How the light captured by the photodiodes becomes an image is discussed in Chapter 5.

The parts of a sensor tell us a great deal about how the light is captured. Manufacturing of the sensors is more involved than might be expected based on their size. Most modern sensors have about 30 manufactured parts and processes. Understanding what goes into the production of the sensor provides insight into the many factors that aid in the functions of the chip. Because sensors are semiconductors, they are often referred to as chips. The common base materials for sensors are metallic

Blooming When the energy exposing a photosite is greater than can be held in the potential well, it can migrate to nearby sites and is called "blooming." The effect is of the lightness spreading or streaking from the oversaturated site.

Anti-blooming technology In order to reduce blooming, modern sensors have electrical microcircuits located next to photosites that "drain" excess light-produced charge from the active sites without polluting nearby sites.

Ferris Wheel. © Christopher Gardner.

wafers, such as those made of silicon. Micro-manufacturing processes such as **photoetching**, **electroplating**, coating, and laminating create a sandwich for which the various layers are designed to perform different functions in the operation of the sensor.

The most prominent features of sensors are the grid of gates, the electronic connections across the surface, the filters, micro-lenses, (Later) and protective and ultraviolet-reducing covering. The gates create the pattern on the sensor surface. They are regular shapes. Most commonly rectangular gates are used; however, the design and function of the sensor can also call for an octagonal or other polygonal shape. The gates are the only part of the sensor that can record the light. Depending on the shape of the gate and the need for electronics, only part of the surface of the sensor is filled with light-gathering ability. The ratio of the light-sensitive surface to the overall size of the sensor is expressed as a percentage referred to as the **fill factor**.

Photoetching Digital imaging sensors are constructed on an etched surface. This is accomplished by using photographic resist (protection) to protect parts of the surface from chemical cutting. These relief portions on the sensor's base material allow other manufacturing processes and electronic connections to be created.

Electroplating A manufacturing process used to create sensors (such as CCD and CMOS) that utilizes electronic energy to deposit a layer of metal to specific locations or pathways within the sensor structure.

Fill factor The ratio of the light-sensitive surface to the overall size of the sensor.

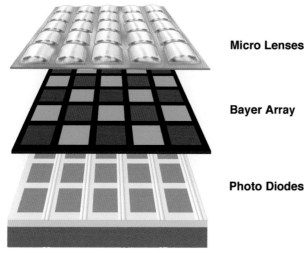

Micro Lenses

Bayer Array

Photo Diodes and Electronics

Figure 3-4 Basic components of sensor.

Lead Sled. © hansenphoto.com.

Depending on the architecture of the sensor and the way it is manufactured, the fill factor will be larger or smaller.

In color imaging sensors, a filter is located above each gate. The light must be filtered to record color because photodiodes do not differentiate color and only respond to changes in the intensity of the light. The organization of these filters is a product of how the image will be made and the sensor type. The most widely accepted method for color capture utilizes three colors—red, green, and blue (RGB)—to capture the color in the scene. Red, green, and blue represent the primaries of additive light, which means that combining various proportions of these three colors can produce all the colors available in light. Using filters to subtract colors can also create color. This method is called *subtractive color mixing*, and its primaries are cyan, magenta, and yellow. While a sensor can be manufactured to use subtraction, this type is not common.

In linear **arrays** filters cover one complete row of the sensor. The linear array has a row of gates covered by a red filter, a row covered by a green filter, and a row covered by a blue filter; thus, this type of array is referred to as a *trilinear array*. These arrays are used in scanners and scanning camera backs.

For camera systems that capture images instantaneously, a pattern of filters must be in place to gather all colors simultaneously. Such a pattern is known as the **mosaic or filter matrix** (also called a **Bayer array**). This matrix is made up of rows, columns, or diagonals of alternating colors. The pattern of the matrix is R—G—R—G alternating with G—B—G—B. In this way, the pattern has green alternating in **perpendicular** directions. There are two basic reasons for using a pattern in which green is predominant. Most important is that green **light** is in the center of the optic sensitivity of the sensor and is most visible to humans. Because detail is more important in image formation than color information and green will record more detail than red or blue, this arrangement of the matrix ensures that the majority of the filters is green. Filters used in the construction of sensors are not pure and will "leak" or

Arrays Arrangements of capture or memory elements in one or more planes.

Mosaic or filter matrix A pattern of filters used to gather all colors simultaneously in a color sensor.

Bayer array A type of filter matrix used in color imaging for many image sensors. The pattern is alternating rows of filters ordered red–green–red–green and green–blue–green–blue. These filters are arranged so that a green site is never next to another green site.

Figure 3-5 Arrangement of filters for photocells for a matrix or Bayer array.

cross over small amounts of other colors beyond those in their chromic make-up. This allows crossover through the green filter meaning that energies from the red and blue spectral areas will affect the green sites on the sensor. The second reason for having more green filters than red or blue is that blue is the noisiest channel and restricting its use produces a cleaner image.

Another way to capture the color is via the Foveon X3® chip. This sensor uses a natural attribute of silicon to separate the colors. Depending on wavelength, a color will penetrate to varying depths into silicon, similar to what occurs with color film. This factor, along with the stacking of three layers of sites, allows the sensor to capture the light's color at each stack of photoreceptors. While theoretically there should be no crossover, there is some absorption of colors as the different wavelengths travel through succeeding sensitivity layers.

Sensors are also manufactured that do not have color capture filters or do not acquire color. These cameras are designed to produce monochromatic, black and white images or are used with tricolor photography. Using a monochromatic sensor to produce tricolor photography, filters are placed in the light path to

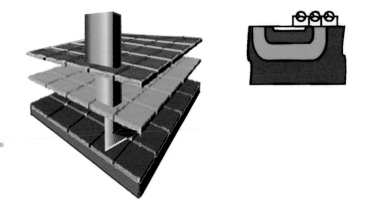

Figure 3-6 and Figure 3-7 The Foveon X3® chip stacks photodiodes to capture all light at a single location. The sensitive areas vary as shown in the colorized patent drawing.

the sensor to make three sequential images—one using red filtration, one using green, and one using blue. A modification of the tricolor photographic process is the three-chip camera, which uses three non-filtered sensors that are positioned to be exposed by light that has been separated into its red, green, or blue spectral portions.

In the most common sensors, **micro-lenses** are often situated above the filters. These lenses are not used to focus the light but instead concentrate the light as it travels through the filter. Concentrating the light means that the light over those parts of the sensor that are not sensitive is not lost. Just as there is a filter for every site, there is also a micro-lens for each site. "After-processing" of the material that etches the surface of a sensor is often used to create the micro-lenses. In order to etch the surface of the sensor, a material is applied to the parts of the sensor's surface that will resist the etching. The "resist" will not allow etching on areas where it has been applied. Thus the etching action of the acids does not cut into the surface below the resist, leaving an engraved surface that forms the underlying structure of the sensor. When the etching is completed, the sensor is heated. The heat melts the resist material, forming it into a micro-lens.

Depending on the sensor, there may also be a glass over the sensor. This provides two benefits. First, the glass provides protection for the micro-manufactured parts, and, second, the glass is often coated with an infrared rejection filter or a "**hot mirror**" to reduce the sensitivity to reflected infrared wavelengths.

Many digital sensors are black on the perimeter to block light to photodiodes on the edges. This sets the lowest level of signal strength or dark current reading. While this does not necessarily correspond to black in the captured image, it becomes the base value for exposure.

The basic building block for digital images is the **pixel**. While there are not actually pixels on the surface of a sensor, people often ask how many pixels the sensor has. While the term *pixel* is inaccurately used in this case, it has become the

Micro-lenses Part of an image sensor above the filters that are used to concentrate light through the filter.

Hot mirror Filter used to block infrared light from the sensor that work by reflecting the nonvisible wavelengths and allowing visible light to pass through.

Pixel Smallest part or building block of a digital image. The name is derived from the words "picture" (pix) and "element" (el). Pixels are used to refer to both the individual parts of the image and the number of photosites on a sensor.

industry method of describing the number of active sites on the chip. Both chip size and gate size vary, and both figure into the number. Many sensors have gates as small as 3.4 μm. As mentioned above, because other parts of the functional electronics use the surface of a chip, the number is not just the math of dividing the surface into the gate sizes. Sensors are designed to meet the needs of specific capture devices. For a small cell-phone camera, the sensor might have slightly more than 300,000 sites, while a high-end digital camera might require 6 million or more sites.

While defining the number of sites on a chip allows for comparisons between sensors, the physical size of the active sensor surface allows other comparisons of the optical functions of systems. Early in the development of sensors, impurity of the silicon caused problems for larger sensors, but, with improvements, the sensors have become effectively the same size as a roll of film. Today, both CMOS and CCDs are manufactured at sizes larger than a roll of 35-mm film, which has an impact on the number of sites that can be placed on the sensor's surface and the demands made on the optics. More of these issues are discussed in Chapter 4 dealing with lenses.

Several architectures are used in the processing of signals for sensors. The architecture reflects the way the chip is configured and constructed to move its captured light from the potential wells to image processing. The architecture allows for speedier handling and **transfer** from the active sensor areas. The transfer can be organized as a linear function or through three potential transferring methods. All the transfer processes use sites or a duplicate array protected from exposure to light and will not be affected by successive exposure. Because the sites or array are not exposed to the light, the charge can be moved from the active photodiodes or active array.

With frame transfer architecture, the entire frame is rapidly moved to an adjacent fully protected array. Another architecture shifts the captured energy to sites that will not accept light and are parallel to the active sensor sites. This is known as *interline transfer*. When the two methods are used together, the procedure is referred to as *frame interline transfer*.

Transfer Refers to a type of architecture used in the processing of digital images on the sensor. The transfer moves the collected energy rapidly. Transfer types include frame, interline, and frame interline.

Olympic Jump 6. © Anacleto Rapping—Los Angeles Times.

As we close this chapter, let us compare the CCD and CMOS sensors. Depending on the way we look at the different sensor types, we will see various advantages or benefits. While both sensors will give good results, there are reasons we might wish to select one or the other sensor type. When discussing image quality and color, the CCD gives better results, and most professionals find that they prefer the quality from the CCD compared to the CMOS. Part of this is because the CCD has higher photodiode sensitivity, which produces a cleaner signal with a better signal-to-**noise** ratio. However, there are also advantages to using CMOS. Because the CMOS is a repurposed computer chip, it can perform many non-imaging functions that **must** be handled with other circuitry for a CCD. Because the CMOS is used in other computer applications, a greater number of them is manufactured, thus lowering the price. The enhanced computing power of the CMOS offers faster readout of the captured signal. The CMOS is more energy efficient than a CCD and currently can be man-

Noise Unwanted electronic information. Noise is common to all electronic equipment and shows up in a digital image as lighter pixels in otherwise dark-toned areas.

Figure 3-8 Frame transfer and interline transfer interline frame.

ufactured with larger surface areas; however, even with recent improvements, the CMOS tends to have a higher noise level because it is more electronically active (the issue of noise is discussed in Chapter 5).

Summary

- The two major sensors used in digital cameras are the charge-coupled device (CCD) and the complementary metal oxide semiconductor (CMOS).
- Photodiodes are the active light receptors on a sensor.
- The sensor has many other manufactured parts in addition to the photodiodes.
- Both the construction and structure of sensors are concerned with the capture of color. Two area array structures are used: the Bayer array of filters and the Foveon X3®.
- The structure of the sensors allows the captured charges from the active sites to be moved through various sensor architectures.

Glossary of Terms

Anti-blooming technology In order to reduce blooming, modern sensors have electrical microcircuits located next to photosites that "drain" excess light-produced charge from the active sites without polluting nearby sites.

Arrays Arrangements of capture or memory elements in one or more planes.

Bayer array A type of filter matrix used in color imaging for many image sensors. The pattern is alternating rows of filters ordered red–green–red–green and green–blue–green–blue. These filters are arranged so that a green site is never next to another green site.

Blooming When the energy exposing a photosite is greater than can be held in the potential well, it can migrate to nearby sites and is called "blooming." The effect is of the lightness spreading or streaking from the oversaturated site.

Charge-coupled device (CCD) An electronic device made up of light-sensitive sites arranged to process the output in a linear process. The charges recorded and output from each site are proportional to the light intensity at each site.

Complementary metal oxide semiconductor (CMOS) Computer chips that can be repurposed to act as a sensor. Because they are not specifically a sensor, as in the case of the CCD chip, they can handle many functions of the digital photographic process beyond capturing the light.

Depletion layer Region between the positive and negative semiconductors of the photodiode. This area is free of electrons or positive "holes." Without free or exposed charges, this region is considered depleted.

Doping Treating the photosite with an impurity. The dopant causes positive "holes" to be formed that allow the photodiode to collect light.

Electromagnetic spectrum (EMS) Range of energy, from long-wavelength radiowaves to extremely short gamma rays, including human observable light. Digital imaging sensors are capable of capturing the visible light and a portion of the infrared energy.

Electroplating A manufacturing process used to create sensors (such as CCD and CMOS) that utilizes electronic energy to deposit a layer of metal to specific locations or pathways within the sensor structure.

Fill factor The ratio of the light-sensitive surface to the overall size of the sensor.

Gate Acts as a control in a digital imaging sensor that allows electrical charge or light energy to have an effect on the operation of the photosite. The gate both allows energy to enter the photodiode and restricts energy flow.

Hot mirror Filter used to block infrared light from the sensor that works by reflecting the nonvisible wavelengths and allowing visible light to pass through.

Indium tin oxide (ITO) A material often used in place of silicon to produce the gates of sensors. ITO tends to provide a better color range because it is optically more transparent than polysilicon.

Metal oxide semiconductor (MOS) A family of semiconductors constructed of metal oxides (such as silicon oxides) that are used to construct digital imaging sensors.

Micro-lenses Part of an image sensor above the filters that are used to concentrate light through the filter.

Mosaic or filter matrix A pattern of filters used to gather all colors simultaneously in a color sensor.

Noise Unwanted electronic information. Noise is common to all electronic equipment and shows up in a digital image as lighter pixels in otherwise dark-toned areas.

Photodiode The portion of a sensor that actually accepts the light, this is a construction of positive and negative portions (*di*, meaning two) that allow the light to be captured. These are also called *sites*.

Photoetching Digital imaging sensors are **constructed on** an etched surface. This is accomplished by using photographic resist (protection) to protect parts of the surface from chemical cutting. These relief portions on the sensor's base material allow other manufacturing processes and electronic connections to be created.

Photons Electromagnetic energy functions in either a wavelength or particle function, and the "photon" is the designation used when the electromagnetic energy is acting as a particle.

Pixel Smallest part or building block of a digital image. The name is derived from the words "picture" (pix) and "element" (el). Pixels are used to refer to both the individual parts of the image and the number of photosites on a sensor.

Potential well Forms in the silicon base of the sensor when an electrical charge is applied to the photodiode. As the photons of the light are captured, a potential barrier is created that holds the captured energy until it can be discharged.

Site The basic unit of the sensor; it is also called a photosite, photodetector, or pixel.

Transfer Refers to a type of architecture used in the processing of digital images on the sensor. The transfer moves the collected energy rapidly. Transfer types include frame, interline, and frame interline.

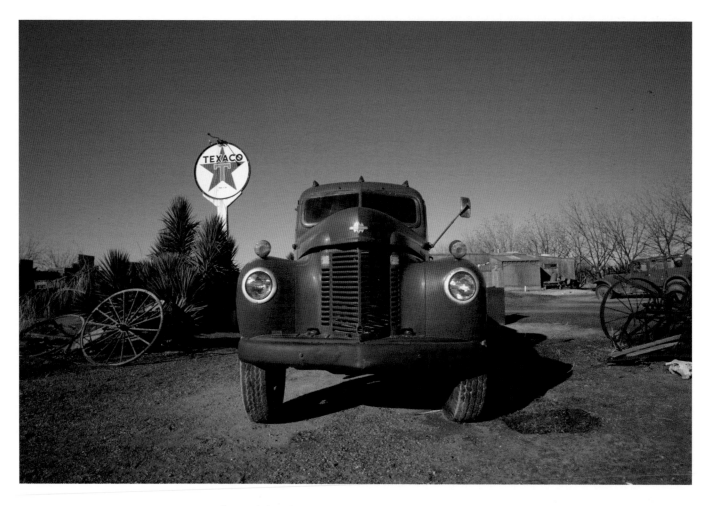

Red Truck by the Pecan Farm. © 2003 Steve Lama.

l e n s e s

Chapter 4 Overview

After a discussion of the basic optics used in the creation of lenses, this chapter looks at basic types of lenses and how lenses control exposure, angle of view, and focus.

Basic Optics

In order to form an image, light must be transmitted from the subject to the sensor. **Optics** accomplishes this task. The principles of optics describe how light is modulated and directed. In the study of optics, **absorption**, **transmission**, **reflection**, and **refraction** constitute major areas. These effects change the direction of light and determine how lenses and image capture work within digital imaging systems.

In photography, absorption is what makes the system work. Absorption can be viewed as the opposite of reflection. With an optics system, the concern is to control how the light arrives at the point in the system where absorption can occur. In the digital camera, absorption occurs twice. Initially, light absorption allows the transmission of light through the lens; then when the light enters the gate of the sensor

Optics The physical study of light and how it reacts to and with other materials.

Absorption Capturing energy when light strikes a surface and the energy enters the material that does not pass through.

Transmission Movement of radiant energy through lenses or other materials.

Reflection Change of direction of energy as it returns from a surface.

Refraction Physical effect on light; as it passes from one medium to another, it bends.

it is absorbed again. Most materials will absorb light energy. This can be demonstrated by an object that sits in the sun and warms up above the ambient air temperature.

Reflection is often considered more important for lighting than capture, as it affects the digital system's ability to capture an image. Briefly, the law of reflection states that the angle of incidence equals the angle of reflection. When a beam of light strikes a surface, the angle is measured between the beam and a line extending perpendicular (the normal) to that surface at the point of incidence. The light will be reflected from the surface at the same angle as measured from the normal. When the surface is curvilinear, the law still holds. In this case, the normal is a line that extends from the surface along the radius of the curved surface at the point of incidence. This means that the angle of incidence is measured from the extended radius, as is the angle of reflection.

Any surface will reflect light. The material, color, and finish of the surface will determine how the light reflects and how much of the light is absorbed—the smoother the surface, the greater the reflection. Glass and transparent materials reflect on the outside and on the inside. Internal reflections are major factors in creating

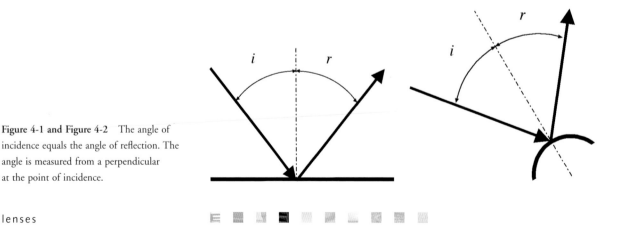

Figure 4-1 and Figure 4-2 The angle of incidence equals the angle of reflection. The angle is measured from a perpendicular at the point of incidence.

Figure 4-3 The yellow line shows the primary focused image of a bright light. The two blue lines show different paths that can create a flare image on the sensor. As these secondary light rays hit the surfaces of the lenses, a small reflection is then focused, moved off the primary focus, and projected to the sensor.

Flare Unwanted reflection within an optical system that is seen as fogging or bright spots on an image.

Multicoatings Multiple optical enhancing and protective layers used on and between lenses and lens elements.

camera **flare**. The generation of flare is a major problem for photographers. Flare occurs whenever light enters a lens system. Because of the number of elements and surfaces in modern lenses, the potential is greater for increased reflection and refraction within the lens system. Whenever light strikes a surface, some of the light can be reflected as well as transmitted and focused. When the light reflects internally in a lens, it can take a new path to the sensor. The stronger the light entering the lens and taking this nondirect path, the greater the disruption that will be seen in the captured image.

While it is easy to see flare when it is caused by a bright light source such as the sun, it also occurs with overcast light. There are two ways to reduce the effect of flare. First, a lens hood or shade can be used. Shading the front element of the lens system reduces the amount of non-image light entering the lens that can become flare. Second, most modern lenses are manufactured with **multicoatings** to reduce internal reflections.

Reflection plays a part in the imaging process, but refraction is crucial to proper operation of digital systems. Refraction is the bending of light as it passes from one material (medium) to another. Light travels at slightly different speeds in different media. When light moves at an angle from one medium to another and transmits **through** the second medium, it bends. If the light is viewed as a short line traveling perpendicular to the light beam, as one end of this short line moves from one medium into another it slows down or speeds up, and this speed change pivots the line, changing the direction of the beam slightly.

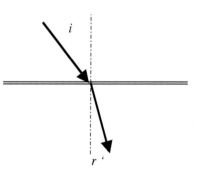

Figure 4-4 Refraction happens as light moves from one medium to another. This changes the light's angle in relation to the surface between the media. The amount of bending is defined by a coefficient of refraction for the combination of the media.

Chart 4-1 Percentage of Reflection Versus Angle of Incidence

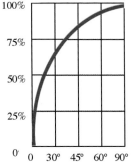

Three variables change the amount of refraction that takes place with regard to a sensor: the angle of incidence of the focused light on the sensor, the absolute index of refraction for the gate material, and the **wavelength** of the light striking the sensor surface. There is a specific range of angles at which refraction can effectively take place. As the angles of incidence increase, more of the light reflects from the surface of the sensor. This means that the amount of light available for absorption into the site is reduced when the angle of incidence increases. While sensor gates are primarily transparent, indium tin oxide (ITO) is more transparent than silicon oxide, but both reflect the light as well. They absorb the maximum amount if the light striking the sensor is close to perpendicular to the surface.

Reflection also plays a role in effective light absorption. As the angle of incident increases, the percentage of the light that can be absorbed decreases, which means that light absorption at the extremes of the cone of illumination of the lens is less effective. The operation of the sensor requires the light to be perpendicular for maximum effect. The angular spread of the light, particularly with films based wide-angle lenses, also reduces the use of **these** lenses where the sensor is expected to capture light on the extremes of the cone of illumination. Very-wide-angle lenses and view cameras with large amounts of camera movement particularly experience problems with fall-off. Lenses designed to function optimally for digital capture must condense or collimate the light to eliminate the possibility of light striking the sensor at an ineffective angle. For a wide-angle lens, when light spreads across the sensor, the angle of incidence increases as the light approaches the edge of the sensor along with natural fall-off of the light's strength.

To address this issue, some manufacturers are adopting the **Four-Thirds stan-dard (4/3rds)**, which originated with video and suggests that the center portion of the cone of illumination be used for digital imaging. The standard specifies an aspect ratio for the sensor's size in relation to the cone of light and allows for interchange-able lenses with particular design specifications. Other manufacturers have altered the

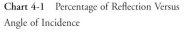

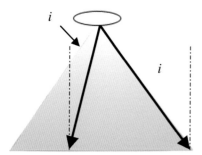

Figure 4-5 Cone of illumination for a wide-angle lens and the angle of incidence.

Figure 4-6 Light refracts as it passes through a prism. As it enters the prism, it separates according to wavelength, with shorter wavelengths bending more than longer wavelengths. As the various wavelengths exit the prism, the light is again refracted and the color of the light is separated even more.

structure of the angle and light-gathering potentials of the micro-lenses to concentrate the light to the photodiodes. Also, some lens manufacturers, as is discussed at the end of this chapter, use additional lens elements to restructure the light to bring it into the sensor as parallel rays.

The second variable that controls the amount of refraction is the absolute index of refraction. This index relates the amount of divergence that is expected to occur as the light passes from a vacuum into the medium. For example, the average index for water is 1.333, while **crown glass** has an average index of 1.524. The difference in indexes shows that the two different media bend light at different rates.

These indexes change, however, due to the third variable—the difference in wavelengths. Crown glass has indexes of refraction of 1.519 for red light and 1.538 for violet light, which means that short wavelengths (blue–violet) will bend more than long wavelengths (red–yellow). This difference in bending based on wavelengths creates **chromatic aberrations** that can be seen within lenses that have large internal

Crown glass A type of glass used for making fine optics that consists mostly of lime and silicate of soda or potash, with no lead.

Chromatic aberrations Caused by lights of different wavelengths focusing at different points. Aberrations can be reduced by the use of multicoatings and compound lens elements.

Two by Two. © Joyce Wilson.

angles focusing on the sensor. This differential bending of portions of the image creates problems. Because the sensor is acquiring the image with color-specific photodiodes, this problem is exaggerated. These effects are seen as color shifts on edges as boundary lines that appear away from the image center **or** with high angles of incidence on the sensor's surface. These colored lines will tend to be seen in complementary color pairs of one long and one short wavelength—for example, red–cyan or blue–yellow. **Apochromatic lenses** reduce chromatic aberration by using compound lenses and special coatings.

Diffraction happens when waveform light passes an edge or through a narrow opening. Part of the light is deflected as it moves past the edge. When part of the light is deflected it slightly softens the image of the edge where the light has been bent. Smaller apertures of most lenses create diffraction, which has a major effect on the ability of a particular lens to be used at smaller apertures with sensors. When light diffraction occurs, it is likely that the light arriving at the sensor's gate has lost part of the intensity. This restricts the effective use of smaller apertures with small gates.

Lens Basics

The two basic types of lenses are positive and negative. Positive lenses converge and focus the light, and negative lenses diverge and spread the light. In simple lenses, positive lenses are primarily convex lenses; the thickest part of the lens is at the center. At least one surface must be convex, but the other side can be convex, planar, or concave. If the center of the lens is the thinnest part, then the lens is negative. As opposed to positive lenses, negative lenses have at least one concave surface with the other side being planar, convex, or concave. Positive lenses have a point of focus while negative lenses do not bring the light to a focal point but instead spread the

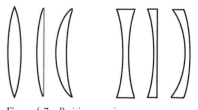

Figure 4-7 Positive negative.

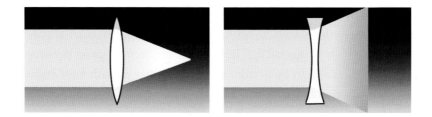

Figure 4-8 and Figure 4-9 Convex lenses bring light to a point of focus and concave lenses spread light. Bringing the light together is referred to as *positive focus* and spreading the light is *negative focus*.

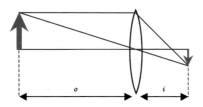

Figure 4-10 Lens diagram and lens equations. The lens inverts the image, but the image processing function built into the system displays the image in its proper orientation either by optical systems or by use of an LCD viewer.

$$1/o + 1/i = 1/f_L$$

$$1/\infty + 1/i = 1/f_L$$

light as though it were emanating from a point (a virtual focus) on the lit side of the lens.

Most cameras today have lens systems comprised of multiple lens elements, or compound lenses. Compound lenses use both positive and negative lenses in combinations that can be constructed to correct a variety of lens problems. Also, these compound lenses have coatings on and between the lens elements that attenuate color aberrations and reduce internal reflections and flare. The requirement for light to be brought to the sensor collimated or with low angular variation requires the use of compound lenses.

Lenses control how light reaches the sensor. This includes focusing the image and controlling how much light arrives at the sensor. Focus is defined by the lens equation. The equation says that the inverse of the object distance (1/*o*) plus the inverse of the image distance (1/*i*) equals the inverse of the focal length (1/*f*). If the object distance is infinity (∞) such that 1/∞ equals zero, then the image distance will be equal to the focal length. When focusing a lens at infinity, the lens distance has its smallest value and the lens is at its most compact. Due to the inverse nature of the equation, as the object distance gets shorter the distance from the lens to the sensor increases. While photographers often discuss focal length as the angle of view, the focal length relates the distance between the lens and the sensor only when the camera is focused at infinity.

Medusa #4_w2. © 2004 Douglas Dubler.

Aperture

Aperture Size of the opening in a lens that allows the light through—larger apertures allow more light to reach the sensor. The aperture is commonly described by the ratio of the f-number.

f-stop The ratio for a lens or lens system computed by dividing the effective diameter or aperture by its focal length; used to define lens aperture for exposure calculation.

Circle of confusion Circle of light created when light from a point source is focused on the surface of the sensor. The size is determined by the size of the aperture and the fineness of the focus. If the circle is acceptably small to the viewer, then the image is considered to be in focus.

The amount of light reaching the sensor is controlled by the **aperture** and shutter speed. The **f-stop** defines the size of the aperture opening in the lens compared to its focal length. The diameter of the lens aperture divided into the focal length equals the f-number. The standard full-stop numbers are f1, f1.4, f2, f2.8, f4, f5.6, f8, f11, f16, f22. The f-numbers continue doubling every other number. More important, each successive higher full f-stop number allows half as much light to reach the sensor. Changing from f11 to f16 (one full stop) cuts the light in half. The reverse is true for descending f-numbers—twice the amount of light enters the lens with each full stop that is opened up.

The aperture not only determines the amount of light that reaches the sensor but also changes the amount of acceptable focus of the image. The depth of field is the range of acceptable focus from close to the camera to the most distant within the scene, although the notion of "acceptable focus" is subjective. Each point of light in the image focuses a cone of light, with the perfect focus making a circle of light on the sensor surface. When the cone of focused light contacts the sensor, the size of the circle formed on the sensor surface changes because of the focus of the lens and the width of the aperture defining the widest part of the cone of focused light. This concept of defining focus by the size of a circle projected from a point is known as the **circle of confusion**. Our willingness to accept a certain size circle of confusion defines acceptable focus. With a smaller aperture, a larger f-stop number means that the lens produces a narrower cone of light with a greater depth of field and close to far image sharpness.

For each f-stop on a lens there is a maximum depth of field that can be acquired. When a lens is focused, the depth of focus is divided such that one-third of the depth of field is in front of the point of focus and two-thirds behind the point of focus. For example, if you focus on an object 10 feet away and have a 3-foot depth of field, then

the image will be in focus 9 (i.e., 10 − 1) to 12 (i.e., 10 + 2) feet from the camera. To maximize the depth of field and include infinity (∞), the lens is focused at the **hyperfocal distance** for the given f-stop. This is done manually by placing the ∞ setting on the lens focus at the f-stop number on the lens's depth of field indicator. In this way, the hyperfocal point of the lens at that f-stop is used for the point of focus. When the lens is focused at infinity, two-thirds of the potential depth of field is lost; however, diffraction at small apertures spreads the light off of the active sensor sites, thus reducing their effectiveness at high f-numbers. Depending on the sensor's architecture, the smallest apertures may lose effectiveness and limit the ability of these stops to hold exposure and sharpness.

Shutter speed constitutes the other control of how much light reaches the sensor. The speeds increase by nominally half or double the preceding shutter speed and thus change the light admitted. Standard shutter speeds are expressed in seconds or fractions of seconds. In this way one-half second is 1/2 where the 2 is the denominator. The denominator of the shutter speed fraction (the lower number) will normally define the shutter speed as a full number. The full shutter stops increase the denominator by doubling: **1**, 2, 4, 8, 15, 30, 60, 125, 250, 500, 1000, Because the shutter stops are doubling in the denominator, each full shutter stop cuts the light in half.

Types of Lenses

For many photographers, an important feature of a lens is its focal length. Photographers tend to use this as a descriptor defining the angle of view, but it only defines the effective length from the lens to the sensor. For 35-mm single-lens reflex (SLR) digital cameras, the focal lengths of lenses might be used to describe angle of view in terms of the film format and will not be the same for a digital sensor unless

Hyperfocal distance Focusing distance that provides the maximum focus that includes infinity at any given aperture.

Figure 4-11 The size of the circle of confusion is determined by the size of the aperture and the distance in front or in back of the sensor where the image is actually focused. As can be seen in the figure, the smaller the aperture, the narrower the cone of light created and the smaller the circle of confusion.

Ponte D. Luis—Porto, Portugal. © brentwinebrenner.com.

the sensor is a "full-frame " sensor. While using the focal length is convenient, it is misleading if the photographer expects similar lens views and effects when the lens is mounted to a camera that uses less than a full-frame sensor.

Angle of view specifies the perspective that the camera captures. The calculation of angle of view is dependent on the diagonal size of the sensor and the focal length. Simply stated, the angle of view is the angle created by lines drawn from each end of the diagonal distance of the sensor and passing through a point centered and at the focal length from the sensor. As the focal length increases, the angle becomes more acute; as the focal length decreases, the angle broadens.

Because the diagonal of the sensor is involved in determining the angle of view, smaller sensors have more acute angles of view than larger sensors when calculated with the same focal lengthened lenses. This becomes quite evident when using lenses designed for standard film sizes, such as 35-mm SLR film cameras that are used with digital cameras. When this lens is used on digital camera bodies with sensors that have smaller diagonals, than the angle of view will be more acute. This is known as the "telephoto effect" because the lens gives an angle of view typical of the longer focal length on the original-size film.

Lens denomination relates directly to the angle of view. Three primary names are used to discuss lenses: normal, telephoto, and wide-angle. Because the sensor size remains constant, the type of lens will depend on the focal length. Normal lenses give a perspective similar to that of the human eye. More technically, the focal length of these lenses is the same as the sensor diagonal.

Lenses that give a magnified view are known as **telephoto lenses**. While these lenses act as though they have long focal lengths (long lenses), the use of compound elements changes the focusing function of the lens such that it can be physically shorter than its nominal focal length. The telephoto's design produces a lighter, shorter lens than if the lens was manufactured with a simple lens structure, but the lens creates a narrower angle of view than a normal lens.

Figure 4-12 The angle of view is defined as the angle created by the size of the sensor and the distance from the sensors and lenses.

Telephoto lenses Lenses that give a magnified view, making distant objects look closer by narrowing the angle of view.

Wide-angle lenses give a perspective with a greater angle of view than a normal lens. Depending on the viewing system, wide-angle lenses might need to have broad angles of view while focusing at a greater distance than the geometry used for calculating angle of view would expect. A common lens design for an SLR camera is the **retrofocus lens**. A retrofocus lens allows the SLR's mirror to pivot out of the way for exposure without hitting the back of the lens.

To achieve a range of angles of view, photographers use zoom lenses. These lenses are a combination of positive and negative lens elements that move to change the angle of view. These lenses compensate either optically by moving elements corresponding to varying the focal lengths to change the angle of view or mechanically by moving elements differentially. While the focal length changes, the f-stop is maintained by a component at the rear of the lens that keeps the aperture and distance to the sensor constant. The zoom lens does not have any connection to "digital zoom." A digital zoom is a reduction of the captured image to make it appear as though the angle of view has been reduced. This is a software application that groups pixels and degrades the detail captured in the image.

Zoom lenses are designed to allow exceptionally close photography; they are considered macro-lenses. A macro-lens maintains a consistent optic focusing distance and aperture relationship, thus allowing each f-stop to function effectively without losing light intensity due to expanded focusing distance.

Regardless of the type of lens, lenses can be focused either manually or automatically. **Autofocus lenses** use a linear pattern of sensor sites to determine when the light pattern uses the lower sites. This happens because the image goes out of focus and becomes larger both in front of and behind the point of focus. The system uses servomotors to move the lens focusing mechanism until the sites are minimized. Because of the nature of images, lines and edges become critical for autofocusing. The autofocus function uses lines and edges for focusing. For this reason, if you try to use an autofocus function to photograph through a fence, the sensor will isolate

Sharton Moorea Lagoon. © Tim Mantoani.

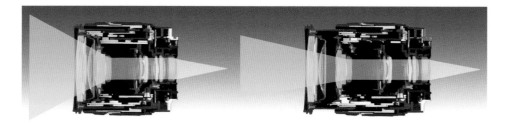

Figure 4-13 A zoom lens changes the angle of view by moving combinations of positive and negative elements. The moving elements are designed to keep the focus distance to the sensor constant while changing the angle of view. (Cutaways courtesy of Tamron USA, Inc.)

the edge of the fence and pull it into focus. If your subject is beyond the depth of field behind the fence, then the fence will be in focus but the subject will not be.

Collimators

Lenses designed specifically for digital sensors use an added lens element (or compound element) that is designed to bring all the light rays reaching the surface

Figure 4-14 All three lens positions create similar focal distances. The first distance (blue lens) focuses in front of the sensor, and the circle of confusion illuminates three sites. The third distance (magenta lens) focuses behind the sensor and also illuminates three sites. If the lens is moved into the center position (red), it will illuminate only one site, telling the camera that the system has reached its best focus.

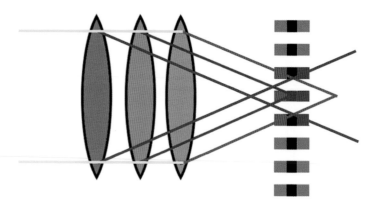

Figure 4-15 Using a collimator creates light that will strike the sensor to maximize exposure.

of the sensor as near to parallel and perpendicular as possible. This is known as a collimator because it forms the light into a column. Photodiodes are very susceptible to a loss of effectiveness as the light varies from being perpendicular to the sensor surface. The collimator reduces the spread of the light bringing the rays of light more perpendicular to the sensor. The column of light can reduce loss of edge exposure on the sensor and can create a larger apparent angle of view for the digital designed lenses.

Collimators Lenses used to form light into a column. Similar to a lighthouse beacon, the light has little spread. These are helpful in digital systems as they bring light into the sensor perpendicularly.

Summary

- The physics of light controls many functions of digital imaging. Most important are the concepts of refraction, the bending of light, and the reflection of light. These affect the way in which lenses focus and control the light reaching the sensor.

- Lenses for both film-based and digital capture have the same basic functions. Primarily, the way lenses focus light and control the amount of light allowed through the lens affect the quality of the image.

- The use of compound lenses adds functionality to the way images are captured.
- Control of the angle of view defines types of lenses.
- Autofocusing of lenses has always been controlled by the use of sensors, and digital capture devices can be used with programs that provide this control on specific lenses.
- The design of lenses for digital capture must take into account factors that are not considered when designing lenses for capture on film.

Glossary of Terms

Absorption Capturing energy when light strikes a surface and the energy enters the material that does not pass through.

Aperture Size of the opening in a lens that allows the light through—larger apertures allow more light to reach the sensor. The aperture is commonly described by the ratio of the f-number.

Apochromatic lenses Compound lenses with higher curvature elements that reduce chromatic aberration. They often have special coatings to further reduce chromatic aberrations.

Autofocus lenses Automatic focus. Automatic focusing lenses use a linear pattern in the sensor to determine focus by movement of lens elements to a point at which the fewest number of sites capture the light.

Chromatic aberrations Caused by lights of different wavelengths focusing at different points. Aberrations can be reduced by the use of multicoatings and compound lens elements.

Circle of confusion Circle of light created when light from a point source is focused on the surface of the sensor. The size is determined by the size of the aperture and the fineness of

the focus. If the circle is acceptably small to the viewer, then the image is considered to be in focus.

Collimators Lenses used to form light into a column. Similar to a lighthouse beacon, the light has little spread. These are helpful in digital systems as they bring light into the sensor perpendicularly.

Crown glass A type of glass used for making fine optics that consists mostly of lime and silicate of soda or potash, with no lead.

Diffraction Changes in the direction and intensity of light as the lightwaves pass by an edge or through a small aperture.

Flare Unwanted reflection within an optical system that is seen as fogging or bright spots on an image.

Four-Thirds standard (4/3rds) A standard for digital camera lenses that allows optimal performance in these digital systems. Sensors do not respond well to light striking at a high angle of incidence, so the Four-Thirds standard uses only the light projected from the lens.

f-stop The ratio for a lens or lens system computed by dividing the effective diameter or aperture by its focal length; used to define lens aperture for exposure calculation.

Hyperfocal distance Focusing distance that provides the maximum focus that includes infinity at any given aperture.

Multicoatings Multiple optical enhancing and protective layers used on and between lenses and lens elements.

Optics The physical study of light and how it reacts to and with other materials.

Reflection Change of direction of energy as it returns from a surface.

Refraction Physical effect on light; as it passes from one medium to another, it bends.

Retrofocus lens A lens that works as though it is a longer focal length lens mounted backwards to the camera, thus allowing the lens to have a wider angle of view than normal. It is positioned far enough away from the sensor to allow the mirror in the SLR design to operate without difficulty.

Telephoto lenses Lenses that give a magnified view, making distant objects look closer by narrowing the angle of view.

Transmission Movement of radiant energy through lenses or other materials.

Wavelengths Distance between successive crests (the high points) of a wave of light—the shorter the wavelength, the greater the refraction. Violet is the shortest visible wavelength; red, the longest.

Floral Reflection. © Tim Meyer 2003.

Chapter 5 Overview

This chapter explores the process that digital capture systems use to convert the light exposing the sensor into a useable digital image. This sequence of steps includes charging the sensor, capturing light energy, moving the charge off the sensor, quantizing the analog signal, and defining the color for each pixel. How much fine detail can be captured is also discussed.

Electronic Sequencing

The lens projects light onto the sensor. Then an image is captured that can be viewed after digital processing. The sequence of steps is not as simple as it looks. The process begins with activation of the camera and ends when the image is written to memory. Turning the camera on does not necessarily prepare the sensor to take pictures. In most cases, the power switch only starts the processor that controls the camera. As with many other electronics, the power switch activates and checks the system's

operations and while preparing the camera. It is not until the camera control unit instructs the system to ready the chip that the sensor will be prepared to accept the light.

Before the image can be captured, several activities take place. Most important among these are metering for exposure and charging the sensor. Because the sensor is made of photodiodes, as are light meters, measuring the light can be done with the sensors. Other functions such as white balance can be accomplished with more advanced systems. Once the exposure is set, the sensor must be prepared to capture light. In order to calculate light values, the sensor must have a uniform charge on all sites. Without this uniformity, it would not be possible to assess the amount and variation of the light striking the individual sites. The camera accomplishes preparation of the sensor by applying an even positive charge to the gates of the sensor. In some cameras, the sensor's gates do not charge until the shutter release button is depressed. If the sensor is charged after the shutter release button is pressed, a delay between the time the button is pushed and the time the picture is taken may result. When the system is positively charged and grounded, the positive charges that were applied to the gates migrate toward the ground, thus giving the positive charge to the potential wells.

At this point the shutter is activated. The shutter may be an optical shutter or an electronic shutter function built into the sensor. Electronic shutters are timing sequences created by accumulating charges on the sensors and then clearing the charge at the end of the exposure time. Electronic shuttering can be part of the interline architecture without compromising the fill factor. Another type of electronic shuttering known as *rolling shuttering* advances sensitivity across the sensor. Rolling shuttering requires more functionality and does impact the fill factor.

Figure 5-1 A positive charge is applied to the gate. Because the system is grounded, the charge on the gate is drawn toward the ground, moving the positive charge to the potential well.

Capture

The electromagnetic energy of the light enters the system, exposes the sensor, and becomes a negative charge at the gates of the sensor. Opposite charges attract; thus the positively charged wells provide a pulling strength that attracts a negative charge. The negative charge created by the light is drawn into the depletion layer of the sensor by the positively charged wells. Depending on design, wells can capture over 300,000 electrons. This is the well capacity. The well capacity in comparison to the noise level will become the range of light intensities that can be captured. The charge continues to accumulate until the exposure is stopped or the maximum well capacity is reached.

Figure 5-2 The photons of the light acting as electrons are attracted to the positively charged well, where they are captured.

If the capacity is reached and energy continues to affect the site, the charge can spill over to neighboring sites. This overexposure effect is known as *blooming*. Blooming occurs when the gate has accepted as much energy as the photodiode can record. At this point, the gate is saturated. If the site is saturated, sites around the saturated site can absorb the excess charge. Anti-blooming operations, however, bleed off the excess charge so it cannot be absorbed by neighboring sites.

Once the light has been captured, several processes occur in order to build the image. The first step is to remove the signals from the active sites. This is normally done in two ways. First, the signal is moved to another light-protected area of the chip that is designed to hold the signal for only a short time. As described in Chapter 2, various architectures of sensors transfer signals from the active sites to these other areas of the chip in frame, interline, or frame interline patterns. The other method of removing the signal is direct linear transfer. As the signal exits the sensor, it moves to the shift register pattern. The shift register is a short-term storage while preserving the ordering required for further processing. While the light can be quite strong, the signal itself will have to be amplified.

Because a complementary metal oxide semiconductor (CMOS) has transistors on the chip, these can be used to amplify the signal before it is moved from the sensor.

Chris & Sam. © Jim Wildeman.

Some designs amplify the signal as the signal is removed from an interline transfer or as it exits the chip. It is a misconception that digital capture collects images digitally. The light falling on the sensor is a continuous form of energy—analog. These analog quantities of light are captured within the exposure range of the sensor, and the signal coming from the sensor is an analog signal.

Electronic Processing of Digital Imaging

In the charge-coupled device (CCD), the basic process is linear. The energy captured in the well is moved off the site at the end of the row. When the energy is removed, a draw is created that promotes migration of the energy from the adjacent site to the newly emptied site. This process is a chain reaction—as a site is emptied, the energy from the adjacent site in that row migrates into the vacant space, and the process continues until the row is emptied of all its charges. Because the CMOS is manufactured with transistors as part of the chip, the charge can be taken off as a CCD or it can be programmed to take the charges off in nonlinear ways.

Two problems that might be encountered with CCDs should be mentioned here. The first is *smearing*, which occurs when light strikes the sensor as the charge is being transferred from the well. In the final image, this will look like streaks emanating from bright areas of the picture. The second transfer problem, fading and weakening of the signal, is due to a loss of efficiency during the charge transfer.

Regardless of how the captured light is moved from the active photodiodes, the signal that is sent from the chip is not digital, as noted previously. The light is captured as analog energy and is exported from the sensor as an analog signal. In order to produce the image digitally, the analog signal must be converted via a quantization process carried out by an **analog-to-digital converter (ADC)**. Further short-term storage can be provided by buffers. Image buffers are short-term memory devices that

Analog-to-digital converter (ADC)
Provides a link between the analog world of light capture and the digital world of signal processing by analyzing the incoming analog signal and changing it to digital code.

Figure 5-3 Sequencing removes the charges from a charge-coupled device (CCD). One charge is removed electronically, leaving a charge gap. The neighboring site then migrates to fill the gap, and all sequential sites transfer its charge. This continues until the row of sites has been emptied of all its charges.

allow for rapid sequential imaging. The signal is then sent to the ADC for quantization.

Quantization

Quantization Process of converting a signal from a set of continuous linear values to a set of related unit values.

The process of **quantization** involves reading the strength of the signal generated by the capture of light in the potential wells and converting it to a digital number. A simplified view of the mathematics is to imagine a wave generated by the sensor being

Figure 5-4 Quantization measures the value of energy and converts the measurement into a number value.

drawn on graph paper with x and y axes. The conversion proceeds by recording values of points along the wave on the graph as binary numbers indicating each point's height. The binary number gives value to the strength of the light striking the sensor. Quantization creates the digital numbers that the rest of the system will work with in the camera, computer, or printer.

The binary system builds numbers based on the power of two. The bit, the basic unit of the system, is 0 or 1. The 0 indicates no electronic value, or Off, and the 1 indicates a charge value, or On. By using a series of 0's and 1's, any real number can be constructed; however, for digital imaging the numbers get quite large and normally units of bytes (8 bits), kilobytes (KB, 1000 bytes), megabytes (MB, 1000 KB), and gigabytes (GB, 1000 MB) are used. The range of signal strength that can be converted to these digital numbers is known as *bit depth*, which most commonly ranges from 8 (2^8 = 256 levels) to 12 (2^{12} = 4096 levels) bits per channel. The bit depth represents the light intensity or grayscale value as captured. Some systems record and/or report out 16-bit channels, but these are interpolated for photographic output purposes.

The ADC calculates the energy value at each pixel location. As captured, the data do not show the scene's color but is captured in the filtered color of each photodiode. All the data from the sensor are transmitted in a raw (uninterpolated) output form; however, most systems are programmed to interpolate the color through the

Waves, Death Valley. © Terry Abrams.

array processor. The array processor is each manufacturer's proprietary process for generating and balancing the color image.

Factors Affecting Exposure

Other aspects related to exposure when using a digital capture device include the effective speed (**ISO**), the sensor's electromagnetic spectrum (EMS), sensitivity, noise, and dynamic range. Like many electronic systems, the sensitivity of the chips in many situations can be adjusted. By changing the electronic gain for the chip, the sensor can vary its sensitivity, thus changing its effective ISO. With adjustable ISO, the sensors can function to address the varying conditions encountered by photographers. Commonly, sensors have effective ISOs from 25 to 400. Higher ISOs produce images of lower image quality primarily because of increased noise.

The light that is captured by the sensor is only part of the electromagnetic energy spectrum. Because of the absorption characteristics of the silicon, indium tin oxide (ITO), or other materials used to construct the photodiodes, their sensitivity differs

ISO (International Standards Organization) Not just an acronym; instead, the name derives from the Greek word *iso*, which means "equal." Photographers are most familiar with ISO ratings of film speeds which are used for sensors.

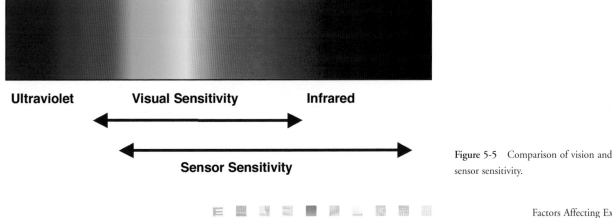

Figure 5-5 Comparison of vision and sensor sensitivity.

from that of the human eye or film. Sensors are sensitive to longer wavelengths of the visible spectrum and extend into the near infrared portion of the EMS. Unwanted infrared exposure is eliminated using either chromatic filtration over the sensor or *hot mirror* filtration. In hot mirror filtration, the longer infrared wavelengths are reflected into a heat sink that absorbs this portion of the EMS. While the sensors far exceed human perception, extending beyond red into the infrared, sensor sensitivity drops off sharply at the blue/violet end of the spectrum. This makes digital capture of short wavelengths less effective than for other areas of the visible spectrum.

A major problem with sensors is that they generate noise because the system is electronic. As electrons move about the sensor, they can stray, affect a site, and be recorded as captured light. While noise cannot be avoided, two major causes of increases in the noise level are long exposure and heat. Heat energy is part of the EMS, and some of this energy can be released as noise.

Three types of noise are common with electronic imaging. *Signal noise* is inherent to all imaging and in many situations is necessary to output tones without **banding**. Without some noise, a uniform tone will create a perceptual edge at its boundary. Sensors have a basic pattern of noise that is systemic. Software applications to the file or using multiple and eliminating exposures can filter system noise. A second type of noise is non-exposure noise often referred to as *dark noise* because it can be seen more readily in darker areas of an image. Last, noise is caused by the electronics of the capture device and its reaction to environmental situations, as well as the capture of extraneous electrons by the sensor's sites. Regardless of the type of noise, when the signal-to-noise ratio is low, the captured level of light is not significantly greater than the noise level, and the image loses quality because of the presence of noise.

One method that some manufacturers use to reduce the effect of noise in an image is known as *dark frame reduction,* which creates a mask based on the dark noise

Banding Occurs when an image has too little color variation; colors tend to become flat and have distinct lines at their borders. Often caused by a limited color space or effects of compression and decompression of the image file.

Noise Level

Figure 5-6 and Figure 5-7 Image noise signal-to-noise ratio.

present in a frame exposed to black. When an exposure is made that is prone to noise, such as a time exposure, a software application is used to create a second exposure with no light reaching the sensor. This dark noise pattern mask can then be used to reduce the effect of the noise in the picture.

High-level sensors are cooled to reduce the noise level. The least expensive option is to use a fan to move air across the sensor to reduce the sensor temperature slightly. More effective are refrigerated sensors that have microrefrigeration units to cool the sensor. The most effective option, used for scientific applications, is a coolant additive system, which uses cold materials, such as liquid nitrogen, to reduce the temperature of the sensor. To varying amounts, these methods of cooling reduce noise

and thus increase the dynamic range. The construction and operation of available sensors varies, and CCD sensors tend to have less noise than CMOSs.

In short, sensors gather light. The tonal range that a device can capture is known as the *dynamic range*, which can be defined in different way by the various manufacturers. Most commonly, the **decibel (dB)** rating and stop range are used. The decibel rating uses a logarithmic ratio between the noise level and the well potential. Sensors vary greatly, but many achieve a rating of 80 dB with an ability to gather a 16,000:1 ratio of light gathering to noise level. The stop rating is more familiar to photographers. Some manufacturers rate their sensors at 16 stops or more. Some digital systems have the ability to resample for intensity and stretch the tonal separation, effectively expanding the apparent **dynamic range**. With the expanded dynamic range of digital sensors, it is now possible to capture light that was beyond the reach of film, approaching the entire range of light we can see.

The physical size of the pixel (photosite's gate) also affects the captured dynamic range. Larger pixels will gather more light information translating into a greater dynamic range. This creates a trade-off between capturing fine detail and light value information. In some systems software is used to mediate the loss of dynamic range captured by small sized pixels. The Fuji® SR sensor uses two photodiodes with different sensitivities at each pixel location to expand the captured dynamic range. In this arrangement, a small portion of the site is less sensitive and thus is used to capture the bright light exposing the sensor. The larger portion of the site is more sensitive to light, thus capturing the lower level light.

Software can be used to reduce image noise. Reproducing the effect of the noise and then removing it to the extent possible reduces the amount of noise in the image. The most common way of doing this is to replicate the exposure time without allowing light to strike the sensor, and a pattern created by only the noise is recorded. Based on this pattern, a masking filter can be created to reduce the noise, because the noise for any given exposure time is quantifiable and reproducible.

Decibel (dB) Unit of measure expressing the relative difference in power or intensity. It is commonly used to compare two acoustic or electric signals and is equal to ten times the common logarithm of the ratio of the two levels.

Dynamic range Measure of the tonal range of light, from brightest to darkest, that an imaging device can capture.

Acquiring Color

Most important for an area array is the generating of a color image. This requires filtration, as sensors do not respond differentially to varying wavelengths (colors), but only to the energy strength of the light within the sensor's sensitivity range. Without using color filters, a sensor will act like panchromatic film acquiring only a grayscale image. Sensors use a matrix of red, green, and blue filters over the photosites that when processed interpolate the color for each pixel. If or when the file is not interpolated, a RAW file is obtained. This means that each pixel will be a light value for the filter color over the site. The RAW file will be discussed further in Chapter 8.

In a simplified model of the interpolation of the color, assume that a sensor has only four sites: two green, one red, and one blue. Because colors can be defined in terms of mixtures of red, green, and blue, when we capture them with such a matrix we have all the information needed to generate estimations of the colors within a scene. While a color can be made up of more than three 8-bit channels, most images can be handled in this form, and this format will be used for our discussion here. In a 24-bit color pallet each-channel at each pixel will have 1 byte, or 8 bits ($2^8 = 256$), of information regarding light levels for red, green, and blue; thus, the file of the image contains 3 bytes of color information for each pixel. A 4-megapixel sensor creates 12-megabyte files in an interpolated file format. In this 8-bit-per-channel arrangement, black or no light will be recorded as 0, and white will be recorded as 255. With color filtration, each channel of red, green, and blue will have levels ranging from 0 to 255. Using 8 bits of illumination information for each of the three primary color channels (red, green, and blue, or RGB), 16,777,216 colors are possible. These colors are generated through an **algorithm** that uses information from more than one site.

While the algorithm is not as simple as the example used here, this explanation gives some idea of the process required. For some sensors, an area array processor

Figure 5-8 Simplified color filter matrix.

Algorithm Set of mathematical methods, rules, and/or procedures used to solve a problem.

Fall Colors. © Ike Lea, Lansing Community College.

handles this conversion. In our example, the values from each of the four sites on the sensor (G–R–G–B) are read and mixed. The algorithm used here sums the values of the two green sites and then divides that figure in half. The red and blue values are used as quantized. This provides a combination of the three colors (red, green, and blue) at an interpolated pixel. At this point, there are as many pixels as sites on the sensor.

A major problem with interpolation using the above Bayer array is that an assumption is made that the light exposing through any of the three filters must only be passing the color of the filter through. These filters are not pure and allow some other colors to expose the site. If the recorded light is from a uniform color area, then the interpolation should be valid, but this is seldom the case. For example, even assuming that no red light strikes the red-filtered site and that the red filter will pass through some blue light, then the photosite will absorb some energy from blue light.

Figure 5-9 Interpolation of a fleshtone color involves interpolating the two green filtered sensors (125 and 129), giving a value of 127. This value is used along with the red value (230) and the blue value (127) to form a pixel value of 230:127:127.

Figure 5-10 and Figure 5-11 The first picture shows a detail of an approximate captured image (a RAW file). The second picture shows the effect of the color interpolation as seen in the final image.

Therefore, it cannot be conclusively said that the blue light does not affect the red sites. In addition to the small amount of color inaccuracy there is the potential for moiré patterns when photographing fine-grid patterns. As discussed in Chapter 3, the Foveon X3® technology stacks the sensors, and while this reduces moiré it is necessary to interpolate some of the color because of crossover exposure on upper sensor areas.

A 24-bit color pallet is not the only file structure available for color in files. An older file type that still has some use on the World Wide Web is an 8-bit color pallet format that provides 256 separate colors, with no other mixtures possible. Even though there are only 256 colors, they can be chosen as an "adaptive pallet" that allows users to select colors to fit the image in the file. Also available are 48-bit files for both capture and saving. These files have 16 bits (2 bytes) per channel, or 65,000 light values per channel. The human perceptual system can only see about 10 million colors, so these bit depths of 8 and 16 bits per channel calculate many more colors than can be recognized by a human observer. It must be noted, however, that some of the colors that can be seen by a normal human cannot be calculated mathematically.

Sampling and Detail

Two components of an image determine its quality: (1) color, which is defined by the color array processor as just explained, and (2) sampling rate. Sampling determines how fine the image divisions are; in other words, it is the ability of the sensor and system to resolve detail. The resolution of a digital image is discussed in terms of pixels per inch (PPI).

Detail in a picture is more critical to a successful image than any other single quality. Resolution is a measure of how well a photographic system can handle detail,

Figure 5-12 High sampling rate; moderate sampling rate; low sampling rate.

or resolve the separation of fine lines. Both physical measurement and perceptual judgment can determine resolution. The sampling rate must be twice as fine as the detail to be captured in the image; a principle known as the *Nyquest limit* states that to image a detail it must be projected on the sensor twice the size of the pixel. From the perceptual point, the resolution must meet the needs of the photographer; that is, the output of the process is acceptable to the photographer.

The most common artifact resulting from **under-sampling** of an image is **aliasing**, which occurs when the resolution is not fine enough to adequately sample a smooth and rapid change in the image, with the result that the pixels making up the edge of the detail are quite apparent. This situation is often referred to as *aliasing* or the *jaggies*. This problem is sometimes addressed by using anti-aliasing software that blends tonal variations into the aliased edge. This softens the step-like look of the aliased detail.

Some systems utilize software to make larger file sizes. Through a combination of software applications, the output file can be modified to resemble one made with a sensor with more pixels. The software increases the size of the image and then applies edge enhancement techniques to provide anti-aliasing and edge contrast. While the resulting image is larger, no more detail can be revealed. If the detail is not captured at the time of exposure, it is not in the image.

Software can also be used to reduce the output size. A photographer might want to make small files that can be exported rapidly or moved quickly, have lower final

Under-sampling Occurs when the capture of an image uses fewer sites than the number required to accurately capture a detail.

Aliasing Occurs when the shape or attitude of a detail in an image changes faster than an acceptable sampling rate and jagged or step-like artifacts form along the contour of the detail.

Figure 5-13 At high enough magnification, a digital image shows aliasing.

Telluride, Wildcat Studios, Stacy Smith.

use requirements, or do not require high sampling rates. In these cases, many cameras allow grouping of pixels to resample the image to a smaller file size.

Often overlooked is how sampling affects color. Because the capture device determines the number of distinct divisions in the image, the pixels, small differences in color are missed with lower level sampling. In order to maximize the color definition in an image, then, the sampling rate must be maximized.

Our discussion of resolution should include a comparison of a digital image to a film image. Because silver halide crystals are one-fourth the size of the smallest commonly used sensor site, film has the potential to gather more information based on surface area. A 35-mm film frame has about 100 million crystals in its emulsion that generate about 14 to 17 million pieces of image information. Taking into consideration the Nyquest limit, a digital sensor would have to have twice the number of sites to gain the same detail as film; however, with digital imaging the critical issue is the number of pixels in the final image application. A comparison of digital to film will be discussed further in the last chapter.

Types of Digital Images

Within the digital format two types of digital images are possible. The least-used method of digital imaging is the *vector graphic.* Vector graphic images are the type used in computer animation and are made up of small, interconnected lines that create a wire frame, which defines the object. This wire frame is then texture mapped with digital detail to allow for a solid image. There are very few specialized cameras that can capture and create vector graphic images. The vast majority of digital images are bit maps, also called *raster graphics.* Where the vector graphic can be used to create either a two- or three-dimensional object, the bit map produces only a two-dimensional image. In a bit map, pixels are located within a grid. The bit map is a

One N. Wacker Drive. Craig Duggan © Hedrich-Blessing.

direct transformation of the site structure on the sensor. When the file is exported from the on-camera processing unit, it is formed into a bit-map image. The points on the bit map are called *pixels* (picture elements). Each pixel has color information in the form of a digital number defining its red, green, and blue values. The values recorded for each pixel are the interpolated or combined light values for the red, green, and blue values for that pixel.

Summary

- Digital capture requires sequencing activities. In order for the sensor to acquire the light accurately, a consistent positive charge must be applied to the sensor.

- The image light is captured in analog form, after which it must be removed from the sensor and then converted into digital values through the process of quantization in the ADC.

- The sensitivity of the sensor is defined by the part of the electromagnetic spectrum and how much light the sensor can capture. The lower level of capture is the noise level.

- Because the sensor captures the strength of light, not different colors, to capture color we must interpolate either filtered light or stacked, separated light.

- Sampling is the way we define the way we capture detail.

- While some digital systems use vector graphic images, the majority of images used in digital imaging are bit-map files.

Glossary of Terms

Algorithm Set of mathematical methods, rules, and/or procedures used to solve a problem.

Aliasing Occurs when the shape or attitude of a detail in an image changes faster than an acceptable sampling rate and jagged or step-like artifacts form along the contour of the detail.

Analog-to-digital converter (ADC) Provides a link between the analog world of light capture and the digital world of signal processing by analyzing the incoming analog signal and changing it to digital code.

Array processor Calculates and establishes the colors for each pixel within the digital camera system.

Banding Occurs when an image has too little color variation; colors tend to become flat and have distinct lines at their borders. Often caused by a limited color space or effects of compression and decompression of the image file.

Decibel (dB) Unit of measure expressing the relative difference in power or intensity. It is commonly used to compare two acoustic or electric signals and is equal to ten times the common logarithm of the ratio of the two levels.

Dynamic range Measure of the tonal range of light, from brightest to darkest, that an imaging device can capture.

ISO (International Standards Organization) Not just an acronym; instead, the name derives from the Greek word *iso*, which means "equal." Photographers are most familiar with ISO ratings of film speeds which are used for sensors.

Quantization Process of converting a signal from a set of continuous linear values to a set of related unit values.

Under-sampling Occurs when the capture of an image uses fewer sites than the number required to accurately capture a detail.

Jewlery. © Glenn Rand.

Chapter 6 Overview

This chapter discusses the concept of exposure and how it applies to the use of digital cameras. After a presentation of the basics, including equivalent exposures, non-metered and metered approaches are considered, including basic daylight exposures, use of reflective and incident meters, and metering. Specific approaches of substitution, tonal placement, dark tone, highlight metering, and average value metering are also presented.

Exposure Basics

Exposure allows the image to be captured. Because sensors, unlike film, cannot accept overexposure and are noisy in very dark areas of exposure, understanding how to set the exposure will provide cleaner and more useable images. Exposure is the capture of light on the sensor. A simple equation defines exposure: exposure (H) is equal to the illumination $(E) \times (T)$, or:

Exposure A measure of the light captured on the sensor. Exposure is calculated with the equation $H = E \times T$, where H is the exposure, E is illumination (the amount of light), and T indicates time (shutter speed).

$$H = E \times T$$

This implies that two variables affect exposure. The aperture of the lens controls the illumination, and the time is controlled by the shutter speed. This equation would suggest that only two variables are at work here, but it has been assumed that the ISO or speed of the sensor remains constant. Sensitivity, however, is variable for many sensors.

Thus, exposure depends upon the ISO, f-stop, and shutter speed. It is important to realize that all of these measures are based on a 2:1 ratio. Each doubling of the ISO rating increases the sensor's sensitivity by a factor of two. As discussed in Chapter 3, both f-stops and shutter speeds are based on this doubling/halving function. This allows coordination among the three factors. When any one of the factors remains constant, then the other two variables establish the exposure; thus, exposure is controlled by illumination and time if the ISO is held constant. Holding the ISO constant is the most commonly used approach for roll film. If the shutter speed is held constant, then exposure is controlled by the illumination and ISO. Finally, if the illumination as defined by aperture setting is held constant, then the shutter speed and ISO establish exposure. Push processing of sheet film allows use of this last approach, but with roll film varying the ISO is not feasible between frames. Although all of these models of exposure are valid for digital capture, varying the ISO limits the range of exposure.

These three controls provide the photographer with various ways to achieve equivalent exposures, which are a series of settings that each achieve the same level of exposure. Because f-stops, shutter speeds, and ISOs are based on the 2:1 ratio, there are many potential settings. By holding one of the three variables constant, manipulating the other two variables can create equivalent exposures; for example:

- If the ISO is held constant, then f4 at 1/125, f5.6 at 1/60, f8 at 1/30, f11 at 1/15, . . . all provide the same exposure.

My Girls. © Joyce Wilson.

- If the speed is held constant, then f11 at 400 ISO, f8 at 200 ISO, f5.6 at 100 ISO, . . . all provide the same exposure.

- If the f-stop is held constant, then 1/125 at 400 ISO, 1/60 at 200 ISO, 1/30 at 100 ISO, . . . all provide the same exposure.

With variable ISO, as mentioned earlier, as the ISO of the sensor is increased the quality of the image deteriorates. This is because the increase in speed reduces the overall signal strength, thus affecting the noise level, which results in greater noise in the image. The increased amount of noise reduces the effective dynamic range.

Basic Daylight Exposure

Basic daylight exposure (BDE) Basic daylight or sunny-day exposure is based on the lighting conditions of a bright, sunny day with the subject in the sunlight. Sometimes this is called the "sunny 16 rule," which states that on a sunny day the exposure will be f16 at a shutter speed of 1/ISO. BDE is an exposure calculated by adding or subtracting f-stops from f16 at a shutter speed 1/ISO to adjust for various lighting situations.

Although metering systems are built into digital cameras, in some situations understanding some principles of light will allow for better exposures. Primarily, daylight and ambient light situations can allow the use of a non-metered approach. With **basic daylight exposure (BDE)**, the photographer can adjust exposure based on the condition of the light rather than on a meter reading. The BDE actually is a list of recommended exposures for varying light conditions. The concept is based on a consistent level of clear-sky sunlight, or the "sunny day" or "sunny 16" rule, which states that on a sunny day the exposure will be at f16 at a shutter speed of 1/ISO. This is the BDE standard. Using this as a basis, the following are exposures recommended in specific lighting situations:

Light Condition	Light Value	Exposure
Sunny day	BDE	f16
Sunny on snow or sand	BDE + 1 stop	f22
Hazy	BDE − 1 stop	f11
Normal cloudy but bright	BDE − 2 stops	f8
Overcast or open shadow	BDE − 3 stops	f5.6
Lighted signs (to see the color)	BDE − 5 stops	f2.8
Stage lighting (bright stage)	BDE − 5 stops	f2.8

Note: Shutter speed is 1/ISO.

The following settings will require adjusting the shutter speed as well as the f-stop:

Light Condition	Light Value	Shutter Speed
Bright city streets (*e.g.*, Times Square), fireworks, night football, store windows	BDE − 6 stops	+6 stops
Stage lighting (spotlighting)	BDE − 7 stops	+7 stops
Night baseball, inside schools and churches (well lit)	BDE − 9 stops	+9 stops
Floodlit buildings	BDE − 11 stops	+11 stops
Distant city	BDE − 13 stops	+13 stops

Light Meters and Basic Metering

With a large dynamic range of some digital capture and potential problems with large light values, exposure of sensors favors underexposure. With proper capture, the detail

in shadows will be realized and the highlights will be controlled without blooming or other overexposure problems.

Determining exposure without metering is possible, but most photography is produced with light metering. Light meters work with sensors similar to those in digital cameras, but the sensors have fewer and/or differently manufactured sites. Metering uses the light received by the sensor to evaluate and then determine the recommended exposure as an f-stop and shutter speed combination based on an ISO setting of the sensor.

Meters evaluate how much light is *reflected from* the subject (**reflective meters**) or the amount of light *falling on* the subject (**incident meters**). Metering determines exposure by using a predetermined value as the average tonal representation in the subject. Middle or 18% gray represents this value. When the light is measured, it is assumed that the meter is reading this middle-tone mix of light values and that this is the value that the photographer wishes to reproduce. Therefore, if the scene contains this average middle tone, then the subject will be captured correctly.

Reflective meters are the most frequently used light meter. The three types of reflective meters are average, programmed, and spot, and the most common of these is the averaging procedure. Average metering takes all the light from the scene, finds the average for all light energies entering the meter, and sets that as the middle value, or the middle tonal mix.

Because light meters use sensors similar to those in digital cameras, using the camera as a reflective meter is a software function. In-camera meters read the light directly from the scene to be captured and set the exposure based on the light coming through the lens. **Through-the-lens (TTL)** meters are the most common meters used in photography today. Software in many cameras automatically sets the exposure using TTL metering. While the "auto exposure" setting gives an overall reading, it is not the only exposure choice on some cameras.

Reflective meters The photocell in a reflective meter reads the light reflected from the subject.

Incident meters The dome on an incident meter covers a photocell that evaluates the amount of light transmitted through the dome. This allows a determination of the amount of light falling on the subject.

Through the lens (TTL) meters Through-the-lens meters are reflective meters that read the light in the optic path after the light has passed through the lens.

Norway at Night. © Ian Macdonald-Smith.

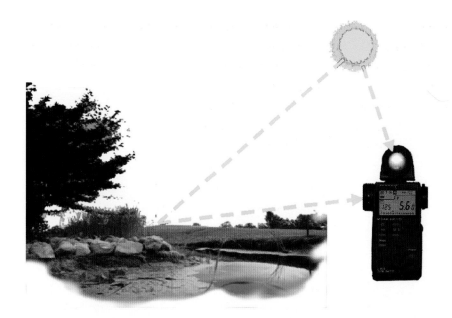

Figure 6-1 An incident meter reads the light from the source, and a reflective meter reads the light reflected from the subject.

The sophistication of sensors and metering associated with them in today's cameras allows metering to be programmed according to specified patterns rather than just as an average or simple spot reading. This allows weighted exposure, or emphasizing predetermined areas of the frame; for example, programming can give a center weight or take a reading from the lower portion of the frame. The most specific pattern is a spot in the center of the frame that acts like a spot meter. Cameras that allow choices of average, pattern, or spot metering have a circuit that changes the number and activity of sensor sites throughout the frame. In many advanced digital systems, the sensor can be used to take light readings from multiple points. These points can be varied depending on the image and can create a specific light weighting for each image.

In general, meters are based on the concept that the metered area, pattern, or spot is middle toned; however, if the subject varies from this middle-tone mix, then the meter will have subject bias and the exposure will not portray the subject accurately. Subject bias can be seen when the subject is made up of a large amount of light tones, such as snow. Average metering will result in the subject being underexposed. Even when the subject is comprised primarily of light tones, many meters assume that the scene is a mix of values that result in middle gray, and the calculated exposure will try to render the image as middle gray. The reverse is true for darker values, in which case the metered exposure produces overexposure.

To avoid subject bias, incident metering can be employed. Incident metering reads the amount of light illuminating the subject. An incident meter uses a translucent dome over the sensor. The dome diffuses the light falling on it and averaging the light illuminating the subject. Unlike a reflective meter, an incident meter is not pointed at the subject but instead is pointed at the camera from the subject's position. Because of the shape of the dome and because it is pointed toward the camera, this meter averages not only the light directed at the subject but also any ambient light reflecting onto the subject surface that will be in the image. Flash meters are generally incident meters.

Substitution Metering

An incident meter is a specialized piece of equipment, and many photographers have only an in-camera meter or a reflective meter; however, the notion of measuring the light falling on the subject still can be used by these photographers to avoid subject bias. Substitution metering uses a material of known reflectivity; for example, gray cards (18% reflective cards) provide the same reflectivity as the settings of meters. Substituting a gray card for the metering value of the scene allows the illumination

on the scene to be measured as it reflects from the known light value card. This establishes the exposure as an incident meter. If the only thing that the metering system measures is the card, then the exposure will be based on the light falling on the area that the card occupies. The angle of the card should be perpendicular to the lens axis to capture the effect of the light as well as the amount of light.

It is also possible to use other materials for substitution metering. With a known relative reflectivity of any material it can be used as a substitute for average metering. The palm of the hand normally reflects about 36% of the light illuminating it. Measuring the light from the palm of hand and reducing the exposure by one stop works well. The clear north sky has a relative luminance equivalent to 18% reflection, or an incident meter. Pointing the reflective meter or the camera at the clear north sky and using that light reading as a substitute for an average meter reading gives the exposure for the light created by the daylight.

Substitution metering with digital capture is a very valuable tool. A system that allows multiple exposure points allows the photographer to use either a gray scale on a color checker or a series of flat-painted (black, middle gray, and white) balls, which can be put into the subject for multiple substitution exposure points. These multiple points allow for control of highlights and shadows, as well as the middle gray of the image.

Tonal Placement

Tonal placement metering involves choosing a specific tone within the scene and adjusting the exposure to ensure that this tonal area will reproduce as desired. To accomplish this, a reflective meter reads the light coming from the chosen area, and the photographer increases or decreases the exposure the number of stops that the chosen tonal area will be from middle gray. A light middle tone will require opening

up one stop, and a detailed highlight will require opening up two stops. Dark tones require stopping down. The camera is stopped down one step for a dark middle tone, two for shadow detail. The tonal placement steps are

- Determine the desired tonal value.
- Meter the critical area of the scene; that area will be metered as middle gray.
- Open up to lighten or stop down to darken the area as desired.

Tonal placement gives control of only one tonal area in the scene. As the chosen tonal area becomes lighter or darker, the rest of the tones in the image will move proportionally in the same direction.

Dark-Tone Metering

Perhaps the most useful non-technical approach for exposure of film is dark-tone metering. While effective for film, it is not well suited for digital capture because of the sensor's inability to accept overexposure. This method, while inappropriate for digital capture, is discussed here because there may be times when film needs to be employed for capture with scanning of the final output used to create a digital file.

Dark-tone metering is a specific application of tonal placement; it commonly uses textured shadow (shadow detail) as the metering point for proper exposure. Many photographers using film have learned, "Expose for the shadows, and develop for the highlights." With film, shadow detail is critical because if it is not captured in the exposure it will not be present in the final developed film image. For digital sensor exposure, dark-tone metering should only be used in calculating exposures where the

highlights are unimportant or are low in relation to the shadow, because this method can lead to overexposure.

With dark-tone metering, the photographer determines what part of the scene will represent shadow detail and then takes a reflective light meter reading in that tonal area. Because the meter is reading for middle gray exposure, it reads two stops more exposure than is required. Stopping down two stops from the meter reading gives the correct exposure. Some photographers make a mistake by choosing the darkest tone in the scene as their dark tone. When they do this they overexpose by two or three stops. Because sensors do not handle overexposure well, this error should be avoided.

Dark-tone metering is part of a multiple-point metering system. With systems that allow multiple-point reading or tonal adjustment for the exposure of selected points, this method can be used to eliminate noise. Within the commonly used digital format, there are 256 gray tones. The purest black would be 0, but using a value of 0 for the black exposure may lead to a loss of shadow detail or noise. For these reasons, it is suggested that photographers use a digital value of 12 for the black setting.

Highlight-Detail Metering

While not as common as dark-tone metering with film, highlight-detail metering is both effective and desirable for digital capture. Similar to dark-tone metering, this technique is a specific application of tone placement when the photographer wishes to select highlight-detailed areas as a critical image area. In this method, the photographer meters an area in the scene that should contain the highlight detail and adjusts the exposure by opening up two stops.

Like transparency film, digital does not handle overexposure well. Because of this inability to accept overexposure, controlling highlights becomes essential in

Mango Tango. © J. Seeley.

situations with bold or critical highlights. Because "blowing out" highlights is to be avoided, with systems that allow adjustments to known values the highlight should be set at 242 in an 8-bit-per-channel system to control for highlight detail. If there is overexposure, **clipping** will occur within either the capture process or post-capture software.

Average-Value Metering

Average-value metering uses tonal placement to produce good exposures. Dark-tone and highlight-tone metering are key to capturing the proper exposure. Because these tones are the extremes of detail in the picture, controlling these areas will allow capture that includes both highlight and shadow detail. The advantage to this adaptation of a tonal approach is that it will reduce errors occurring because of pictures that are tonally biased to either a bright tone or a dark tone within a majority of the scene. Working within a range of light allows capturing detail in both shadow and highlight. The photographer selects and meters these two tonal areas, which establishes a range of tones defining the middle portion of the scene that includes the important detail of the image. By dividing the two tones, the midpoint becomes the exposure. If the midpoint is not clearly determined, then exposure should tend toward underexposure by moving the exposure point toward the highlight. With adjustable-value systems, a black point value of 12 and a white point value of 242 are recommended.

Summary

- The basic concepts of exposure hold whether using film or digital capture. Exposure is controlled by the amount of light, the time of exposure, and the speed of the sensor.

Clipping When the amount of light exposing the sensor exceeds its ability to record all the energy, the system eliminates these higher energy levels or software eliminates higher digital number values from the image file.

Lucas. © Tim Mantoani.

- Equivalent exposure uses the interrelationship between the quantity of light as expressed in f-stop, shutter speed, and the speed rating of the sensor to create a set of exposures. Holding one of the three variables constant and then varying the other two creates equivalent exposures.

- Instead of a metering system, basic daylight exposure can be used to determine exposure based on observed lighting.

- Incident light meters read the light falling on the subject, and reflective meters read light reflecting from the subject. Reflective meters can determine the light reflecting off of the entire subject or just a portion.

- A reflective meter establishes the exposure by averaging all the light reaching the meter. By substituting an object of known reflectance, taking a meter reading at a critical point in the scene, whether shadow or highlight detail, or determining an average value by selecting both highlights and shadows, the average meter provides an accurate method for placing exposure for digital capture.

Glossary of Terms

Basic daylight exposure (BDE) Basic daylight or sunny-day exposure is based on the lighting conditions of a bright, sunny day with the subject in the sunlight. Sometimes this is called the "sunny 16 rule," which states that on a sunny day the exposure will be f16 at a shutter speed of 1/ISO. BDE is an exposure calculated by adding or subtracting f-stops from f16 at a shutter speed of 1/ISO to adjust for various lighting situations.

Clipping When the amount of light exposing the sensor exceeds its ability to record all the energy, the system eliminates these higher energy levels or software eliminates higher digital number values from the image file.

Exposure A measure of the light captured on the sensor. Exposure is calculated with the equation $H = E \times T$, where H is the exposure, E is illumination (the amount of light), and T indicates time (shutter speed).

Incident meters The dome on an incident meter covers a photocell that evaluates the amount of light transmitted through the dome. This allows a determination of the amount of light falling on the subject.

Reflective meters The photocell in a reflective meter reads the light reflected from the subject.

Through-the-lens (TTL) meters Through-the-lens meters are reflective meters that read the light in the optic path after the light has passed through the lens.

Zenhome1. © Anacleto Rapping—Los Angeles Times.

Chapter 7 Overview

This chapter looks at the process known as *digital workflow*, which has five basic steps: camera control, exposure, neutral balance, capture, and storage. These steps allow your creativity to be realized. The chapter also presents three approaches to photographic problem solving: a digital camera tethered to a computer in the studio, a remote removable media camera system on location, and digital capture. The techniques explained in this chapter are for camera systems that allow variation from automatic settings. Although this discussion is primarily intended for various types of professional camera systems, many of the methods or functions addressed here apply to prosumer and consumer cameras as well.

Workflow

Digital workflow refers to the steps used to acquire an image. While the full workflow process continues beyond the act of capturing the image, this chapter focuses

only on the formation of the image on the sensor, its transfer to filing, and global control of the image within the image capture sequence. Many think that the technical aspects are critical to making images. As with all photography, however, the resulting image is not entirely dependent on the equipment and its technical function alone; rather, the strength of an image is the product of the eye and mind of the photographer teamed with the capture abilities of a digital system. While not technical, creativity is the first and most important step in the workflow. Though creativity is not involved with the operating system, at times the system can dictate the limits of creativity.

For this discussion, we will consider a **tethered system** and a non-tethered system. Tethered systems use the functions and memory of a computer or external memory and control unit, while non-tethered systems use removable media and on-board memory and control to handle the imaging process. The major differences between these two methods are that a non-tethered system offers the freedom of not being attached to a secondary piece of equipment but a tethered system offers the enhanced control functions and larger display provided by a computer.

In a non-tethered system, the on-board functions replace the computer or control unit, and because of the sophistication of the camera controls this is accomplished without major changes in workflow. Regardless of whether or not the camera is tethered, there is no requirement that either type of system must be confined to or excluded from the studio. Some camera systems can be used in both modes, but for this discussion of workflow it will be easier to view them as separate and distinct systems.

This discussion of technical workflow does not attempt to present every potential operation for every camera system. Manufacturers offer varying software protocols, and applications and processes will differ. For this reason, it is important to read and understand the operation manual of a particular system.

Tethered system A tethered system uses a cable or tether to connect the camera to a computer or external control unit.

Basic Technical Steps

After the creative portion of the image-making process, some basic technical steps in digital capture workflow follow, regardless of tethering. Some basic steps include camera operational controls, neutral tone balancing, capture, global corrections, and writing to storage. The order of some of these steps may vary slightly and may be augmented in some systems. The ability to review images in some workflows allows ongoing recognition and correction of problems and adds flexibility to the process. There are several points in the workflow when adjustments can be made.

One issue facing all photographers is cleanliness of the imaging surface. It may seem out of place in a discussion of the workflow, but maintaining the cleanliness of the sensor saves considerable effort in the workflow after capture. If film gets dirty, it can be changed between exposures, but digital sensors remain in place for multiple uses, and any imperfections on the sensor's surface will show up on all of the images; therefore, the care, cleaning, and maintenance of the sensor are ongoing concerns. Systems with interchangeable lenses or changeable backs are particularly susceptible to dirt and defects on the surface of the sensor which can degrade the quality of the final image. Cleaning a sensor is not simply wiping the surface; it is critical to follow the manufacturer's directions.

Storage Formatting

Whether a system is tethered or not, the image must be recorded in some type of storage system. Each camera or system will save images in a particular way; therefore, before capturing an image, formatting and checking the storage of the camera or system is important. Several types of removable media are available, and the formats

Retro Clock. © Ralph Masullo.

are not necessarily compatible. For tethered camera systems, it is critical to ensure that enough space is available on the computer's storage unit to acquire and save the images that will be made.

Camera Controls

Camera operational controls include image positioning, focus, capture speed, and aperture controls. These systems may be automatic or manual, but it is important to keep in mind that it takes more time to correct an image later than it does to properly capture the desired the image on location. Doing it over in some cases is not an option. The use of a tethered system can be compared to using a single-lens reflex (SLR) system with a large image size. The computer monitor can be used to check compositional elements, lighting, depth of field, and focus and offers the best representation of the captured image, as it is more accurate than what is viewed through the camera's optical viewing system.

Exposure

It is best to start with an exposure method used previously. Knowing the ISO setting for the sensor allows the use of a light meter or non-metered system to establish the starting exposure point. Regardless of the way exposure is calculated, manually or automatically, metering the important highlight and shadow details establishes the level and range of exposure. Overexposure is not correctable after exposure, and noise in underexposed areas can destroy detail. Even with a liquid crystal display (LCD), care must be taken to avoid overexposure. Because of the small size of many on-camera LCDs, it may be difficult to identify and avoid blooming or overexposure.

With a tethered system, the level of the highlight can be measured and then brought into the range of the sensor by adjusting the exposure. In this way, exposures, as seen or as measured on the display, can be adjusted to meet expectations. Typically, a **histogram** function or overexposure warnings are used for exposure problem correction. The histogram graphs the number of pixels in an image at each of the captured light values. When the histogram shows a large number of pixels at the white end, this is an indication of potential overexposure. The control on many cameras allows setting the exposure by adjusting high and low histogram levels to fit within the exposure limits. By using this graphical interface with a slider, histogram, or other representation, control is gained for selected areas of interest and potential exposure errors are avoided.

Because overexposure is the more significant concern, exposure must be set to limit the effect of the brightest critical area of the image. A safe point is to set the important brightest portions of the image at a value of 242 or below (on a 24-bit color space). While exposure is used to limit the highlight's effect on the sensor, lighting effects are used, when practical, to bring shadow detail into the useable exposure range.

Histogram The histogram is a graph that shows how the light values in the image are distributed. The height of the lines in the histogram represents the number of pixels that are found in the image at any particular value.

Neutral Balance

Color management of digital imaging is a major issue. Neutral tone balancing is the first step in controlling color reproduction. Once exposure levels have been established, the light's neutral balance must be established. The human perceptual system holds color, brightness, and other aspects of vision constant as light color changes. When our mind holds constant an impression of neutral tones on a grayscale, this concept is known as **perceptual constancy**. We see and relate to a white house as white even though it is overcast and the light is actually blue in cast. Likewise, we do

Perceptual constancy Our perceptual systems find it easier to hold things constant rather than relearn them continually. This means that when we have learned a color we will interpret it consistently regardless of minor fluctuations in the actual color simulation.

not notice the yellow cast of continuous (hot) lighting when in a light-controlled studio. For film, balancing for light bias can be accomplished with filters, but digital capture software in the system allows correction without any additional equipment.

Our inability to see subtle light color changes and our perceptual constancy force us to rely on the sophistication of sensors and software to aid in balancing the captured light. It should be noted that if false color is used (e.g., gels or colored lights), these lighting effects should not be applied when neutral balancing. Placing and then color measuring a known neutral tone in the scene is the most common way to achieve neutral balance. This may involve the use of a gray card or color checker in the scene or a neutral-light-penetrating lens covering. Because the sensor reads color, the mix of light of the known neutral can be adjusted to reduce the color bias of the light.

When a neutral target is in the scene, balancing is accomplished by selecting the target on the computer screen or display or reading the total light penetrating the translucent lens cover; recording the red, green, and blue (RGB) values; and adjusting the color to neutral or equal values of red, green, and blue. This is done in the system by adjusting the captured light values of each channel so that they approximate the same value. A pure neutral means that the values in each channel have the same numeric value. Most systems allow for an automatic adjustment that will apply either a gain change to the sensor or an after-capture correction that achieves balance.

While these systems can operate automatically, some situations, such as capturing light from a sunset, dictate manual adjustment of the neutral balance to achieve the desired colors. To allow the capture of the warm color produced in a sunset, manual settings or use of the camera's programmed daylight balance are recommended.

Batch processing occurs when software modifies all files after the images are captured and stored. Batch processing allows the capture of images without adjusting the

Batch processing When an image has been adjusted to a desired look, the steps used to make the adjustments can be saved, and the algorithm can be used on succeeding images made under the same conditions. If all the images use this algorithm at one time, then they have been batch processed.

light for each shot. Gray balance information obtained during setup is applied in the background as the images are processed or after capture processing by imaging software. Known light conditions can be saved as light **profiles** that can be used later in similar situations. Many software packages come with preset light balances for such use. These light profiles are for common light sources and allow speedier workflows; in addition, they can be applied to image files that have been previously saved.

Balancing the light for capture applies an input profile to the sensor or file that allows the image to be more faithfully reproduced in the digital system. Profiles are the function that coordinates input to output and provides the consistency that the system needs. Without going into detail with regard to how profiles actually work, there are reasons for choosing a particular profile system. Input profiles maintain information from the captured image. This information, which can be saved with the image file, makes archiving an important function for the system. While there will be consistency in output from whatever printer is used, the output will not necessarily be maximized using this type of system.

Beyond color balancing the image to the light, many systems allow adjustment of the way the sensor relates to the dynamic range of the light in the scene. This is known as a **gamma adjustment**. By changing the gamma, the image is portrayed with more or less contrast. A gamma setting of 1.8 is used when the image will be output to a print material and a gamma setting of 2.2 is used for either video or monitor-based presentations.

Capture

With a tethered camera system, a test shot should be made for a final check of the basics: focus, lighting, and contrast. The small size of LCDs on most camera systems does not allow checking fine focus, but it does allow a check of composition, con-

trast, and overall exposure. For tethered systems, the larger size of most computer monitors makes these operations easy. The options for capture vary depending on the system. Some tethered systems offer the option to fire the shutter from either the camera or the computer. Other systems require shutter operation from either the camera or the computer, but not both. Operating from the computer allows control of the software along with the capture sequencing. The major advantage of this type of operation is a higher level of control.

Operation from a computer is not always advantageous. In many situations, the best operation mode for a camera is on-camera operation. Smaller format, non-tethered digital cameras can be held in the hand, thus providing flexibility and movement while photographing. This is particularly desirable when photographing on location or in action situations where the photographer or the subject is moving.

Regardless of the method used to make the exposure, sequencing of the process must take a particular path. As was explained earlier, the sensor must be prepared to accept the light charge. While this is not a problem with newer camera systems, allowances may have to be made for charging the sensor. For older camera systems with camera backs, this is accomplished by using a two-part cable release that activates the sensor before allowing the shutter to open. This sequencing issue is why some lower end cameras do not capture the image when the shutter release is pressed but delay for a short time.

Storage

Once the image is captured it must be stored. Regardless of how the output will be used, at this point the image should be saved in its purest form. With cameras that will write a RAW file (an uninterpolated file), use that file format. When the camera has built-in compression, the compression function should be turned off, if possible.

If it cannot, then save the file in the largest file available. Keep the original file as it was captured. Use copied files for post-capture corrections or manipulations. Data are lost or changed anytime a file is changed, but data can be copied faithfully, so an original file can be duplicated as many times as necessary to correct or manipulate the image; however, once the original file has been changed it cannot be restored. The next chapter addresses file types and compression.

Approaches

This part of the chapter follows the digital workflow through three situations to show three different approaches to digital capture, beginning with a studio illustration, followed by a photoshoot outdoors, and finally a situation in which a difficult lighting problem must be solved.

Scott Miles: In the Studio

Perhaps the easiest workflow to follow is in the studio with a tethered camera. The steps in this situation cover all the major areas discussed thus far, and the tethering of the computer allows greater interaction within the workflow. The studio environment offers great advantages with regard to saving time and providing maximum control of the many variables, but these advantages alone do not make a good photograph. After all, it is what is in the picture and how the image is organized that will make the difference; thus, the choice of subject and its styling must be of greatest importance.

One of the advantages of using a digital camera is styling within the frame. Because many digital systems support live viewing with the camera stationary, ele-

ments of the image can be moved within the scene and viewed on the monitor to see the effect of these choices in the frame of the image. This setup allows the styling to be very exacting. Details such as locations of and interactions between elements of the image can be managed. Little things that might go unnoticed in film-based photography can be addressed, such as unintended interactions between elements or wrinkles in background materials. The computer screen highlights these little details, as well as major structures apparent in a viewfinder.

After or in concert with the styling, the lighting must be established. Regardless of the sophistication of the digital camera and supporting software, lighting is key. Working in the studio provides ultimate control over lighting. While adjustments to lighting may be carried out in later stages of the workflow, it pays to spend time creating the lighting that will produce the desired atmosphere and illumination. Many modifications can be made in post-production processing, but the effects of bad lighting are difficult to eliminate. When the lighting has been established, the camera and capture functions really begin to operate. With a tethered system, the issue of for-

Figure 7-1 Scott Miles uses the monitor to compose and focus the camera.

Figure 7-2 Lighting is created to provide exposure and the mood of the photograph.

matting memory is eliminated from the workflow; however, it is important to make sure that the computer has the required space available to store the images.

The camera controls include focus, lens choice, aperture, shutter speed, and, in some cases, camera movement. With a tethered camera, the focus can be viewed and evaluated on the computer. As explained in Chapter 4, choices of angle of view, aperture, and movement may create capture problems if not adequately thought out and addressed. The use of wide-angle lenses or camera movements can particularly alter a sensor's ability to acquire the proper level of light needed for exposure. At the extremes of the coverage of the lens of distance or off axis with camera movements. Depth of field is another issue effectively addressed by use of a tethered digital camera, as the tethered camera allows more efficient handling of any problems arising due to small apertures. Because the camera is interacting with its capture software, adjustments to small aperture problems can easily be addressed by changing exposure points in the system.

Thus far in our discussion, the image on the computer has been used to style and to adjust the light, but not to control the exposure. Setting the exposure, then, is the next step in the workflow. Any appropriate metering method can be used, but the tethered camera offers greater exposure control and metering is not required. With the tethered system, exposure is set by adjusting the shadow point and the highlight point using tools in the capture software. This adjustment of light values prevents a loss of detail in the extremes.

With digital capture, controlling highlights is extremely important. Using the system's software, the exposure for the brightest highlight can be brought to a value of 242 to avoid potential blooming or clipping. A grayscale can be placed in the scene after the lighting is set so a tonal range can be metered, with the software adjusting the highlight value against a known tonal value.

The highlight exposure level is adjusted to avoid clipping, but if not enough light reaches into the shadow areas these details will either be lost or contaminated by noise. Because the light environment in the studio is controlled, the shadow detail can be addressed with fill light. Using the grayscale, light can be changed so that the black level has a digital value of at least 12. By placing a grayscale in the image, the lighting and exposure can be set within the limits of the sensor. The exposure is set to the highlight (white value at 242), and the lighting is modified to set the black point (black value at 12).

As either the highlight or shadow point for exposure is moved, the other will also move. A strategy that addresses both ends is possible in the studio. The exposure is set for the highlight, and then the shadow level is moved by adding or subtracting light until it reaches its desired level. The effect of these adjustments can be seen in the histogram, with all exposures falling between 12 and 242.

At this point, the capture needs to be neutral balanced. A good way to do so is to place three small, neutral-toned balls in the scene. These balls can be easily made or purchased. They should have a matte finish in white, gray, and black and should

Figure 7-3 A gray scale is placed into the scene and used to set the white and black exposure.

be mounted on flexible wire attached to a base. These three balls provide all the tonal values necessary for neutral balancing. There are two reasons to use this type of device for neutral balancing. First, the spheres will react to the light in the scene and the surfaces of the tone balls will show the effect of both the main and fill lighting. Depending on the type of capture system, neutral balance can be found in numerous points on the balls. Second, color biases can come from the subject even though the color is perceived as neutral.

When colored gels are used to change the color of the light, these gels should be removed from the lights when neutral balancing. Light reflecting from colored surfaces will change the color balancing, and the balancing points should be carefully placed to avoid color contamination from reflecting fills.

At this point, the first exposure is made. Because the camera is tethered, the computer can be used as instant proof of the capture. If there are any noticeable prob-

Figure 7-4 Neutral-toned spheres can be used to neutral balance the image. Also a color checker can be used for checking.

lems, the process can be modified at any point above. It is also possible to adjust some of the software controls, such as gamma control, to establish the desired contrast in the image.

Christopher Broughton: On Location

Images by Christopher Broughton are examples of unique digital images that have been made on location, far away from the studio and without use of a tethered system. When using digital cameras on location, the workflow starts well before reaching the location. Planning is crucial for a successful shoot. Operating away from a base limits what can be accomplished. Everything required to support the photography will have

Round Lake, Alaska. © 2004 by Christopher Broughton.

to be brought with the photographer. In planning, multiple removable media are reformatted to ensure enough storage for the time on location and the functionality of the media. Also, batteries are charged. Because the shoot will be away from recharging potentials, extra batteries are also packed to enable extended shooting. Beyond these two specific digital capture requirements, all other items, such as tripod, lens shades, etc., become part of the planning for location photography.

On location, the capture workflow begins. As with all other photography, framing the image is the first step. In this example, a perspective-correcting lens was used to allow building a panorama image without a special camera body or an excessive wide-angle lens. The perspective-correcting lens can shift on one axis, which allows it to point at different angles without changing the position and attitude of the sensor. This allows framing to produce three successive images without a change in perspective between the images. Without a change in perspective, the resulting montage image can be easily assembled.

Figure 7-5 Prior to going on location, removable media should be formatted to facilitate making pictures without delays.

For the image, Round Lake, Alaska a tripod was used, and the camera was leveled. When the camera is leveled with its back vertical, the tripod holds the sensor in a true vertical position such that, with the lens mounted to shift horizontally, the image path is across the horizon. Because this particular image was shot into a setting sun, a basic exposure was chosen with the knowledge that a histogram would be required to achieve the correct exposure. Once the test exposure was made, the histogram was viewed on the LCD. As would be expected, the histogram showed a strong spike where the sun's energy was captured. Because the sun is the brightest object in the scene, it was allowed to be exposed and show at the white end of the histogram. It was important that the shadow detail was not lost, and that was confirmed on the histogram.

In the studio, neutral balancing would be the next step, but in nature white balance destroys the color of the light. For this picture, a preset "daylight" balance was chosen to allow the color of the light to affect the image. If the color of the light was neutralized, then the sunset color would have been lost. At this point, the lens was moved to the extreme position on one side and the first picture was taken. The

Figure 7-6 While the image is framed, a level is used (see inset) to maintain level horizon.

lens was then shifted to the center or "zeroed" position, and the second image was captured. The zeroed position of the lens can be easily found as the mounting has a click registration in this position. Finally, the lens was shifted to the other extreme end, and the last image was captured. Because the camera used had a fast recycle time and large buffer, the three captures were taken very quickly, in less than two seconds. The speed of the successive shots eliminated major changes in the landscape during the exposure. After the images were captured, the three separate images were composited using imaging software to create the panorama.

Russ McConnell: Overcoming Photographic Limitations

The image constructed by Russ McConnell is an example of how understanding the capabilities of digital capture allows the photographer to overcome problems. While the image appears to be a normal architectural interior photograph, digital imaging enabled its production. As is often the case, the people who were in charge of this space were not aware of what photographers need to make such an image. During the arrangements to photograph this space, discussion moved to the amount of lighting equipment that would be used and assurances were given that enough power and outlets would be available; however, when the photographer arrived on the site, it became clear that not enough power was available to handle the lighting. Only four of the 60+ lights that had been brought to the shoot could be used at any one time. Rather than scrap the shoot, digital capture with post-capture layering was utilized.

The workflow for this image became dependent on its being captured within the digital environment. Being able to project the workflow into post-capture layering was a requirement of this image. Because there was not enough power to light the entire room adequately for a single capture, the image would have to be captured

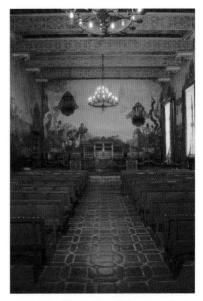

Figure 7-7 The ambient light present in the room prior to lighting.

in sections and the image would be composed using lighting layers in post-capture processing. Because digital capture cannot accept successive exposures, separate exposures for each lighting section needed to be made. To aid the post-capture processing and reassembly of the final image, careful notes were taken as the shot progressed.

The lighting was created in sectors to deal with areas or details. As the scene's lighting was segmented, so was the image's capture. In this image, the 18 captures were layered using post-capture software. With the camera secured on a tripod, the point of view remained constant for all the exposures. It was important to keep the exposure consistent for the later layering. It was also necessary to keep the f-stop constant. If the f-stop had changed during successive exposures, the depth of field

Figure 7-8 and Figure 7-9 Two of the lighting patterns that became layers in the final composite.

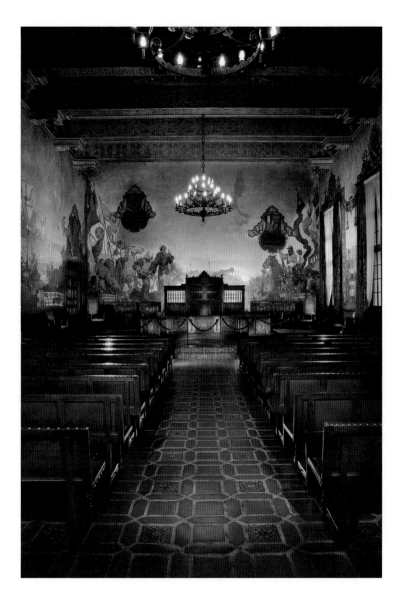

Santa Barbara Courthouse Mural Room. © Russ McConnell.

would have varied, causing image misalignment and size variation when the focus changed.

Segmenting the image capture created a series of workflows. In each section of the image, the light had to be set up to acquire the desired pattern or detail. Because the light in the room was mixed, each section of the capture required an individual exposure. The individual exposures created a baseline for all of the images as they were merged.

While each layer had individually calculated exposures, the neutral balance had to remain constant across layers for color consistency. For this shot, the majority of the lighting was tungsten, so that was the chosen balance for all 18 layers. The choice of white balancing for tungsten lighting gave the external light coming through the windows a cool blue look.

Summary

- Even though the technical concerns are important, the care taken to style and design the photograph is critical to creating great images.
- The five basic steps in digital workflow are camera control, exposure, neutral balance, capture, and storage.
- Digital workflow can be used with a tethered camera in the studio or on location with a stand-alone system.

Glossary of Terms

Batch processing When an image has been adjusted to a desired look, the steps used to make the adjustments can be saved, and the algorithm can be used on succeeding images

made under the same conditions. If all the images use this algorithm at one time, then they have been batch processed.

Gamma adjustment The slope of the curve formed by graphing the input values of the captured image compared to its output values is referred to as gamma. A gamma adjustment is a computer control that changes the relationship between input and output values.

Histogram The histogram is a graph that shows how the light values in the image are distributed. The height of the lines in the histogram represents the number of pixels that are found in the image at any particular value.

Perceptual constancy Our perceptual systems find it easier to hold things constant rather than relearn them continually. This means that when we have learned a color we will interpret it consistently regardless of minor fluctuations in the actual color simulation.

Profiles Profiles are computer tools that coordinate the input of digital images to their output.

Tethered system A tethered system uses a cable or tether to connect the camera to a computer or external control unit.

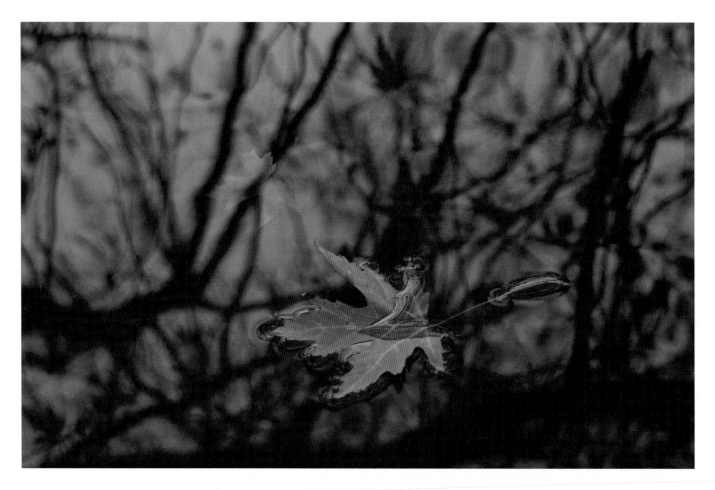

Leaf on Water. © Ike Lea, Lansing Community College.

files

Chapter 8 Overview

This chapter deals with how the data included in an image are stored and used and describes the parts of the file itself and how the files can be reduced for easy transmittal. Several file types are introduced to show the wide variety of files available and their specific applications.

File Basics

When the image is captured and converted to a set of numerical values, we need to secure the data and make them portable. This takes place at several points in the process, and because of the varying requirements within the system the method for holding the data changes. As discussed earlier, the first place the information has to become transportable is in the architecture of the chip. For the most part, we can consider this short-term storage, and this captured file requires conversion to binary, digital numbers.

Beyond the concept of a captured file are three other common file uses. Working files require certain levels of flexibility to allow creative manipulations of or corrections to the image. Next the file is also the archive form for saving and making the data permanent. To do this requires a file that you can write, record, and later reconstruct. Finally, certain files are designed for the communication of the image information to output or transfer.

While the captured file is not useful to us beyond its function within the camera and is changed from an analog form to a digital file, it displays the basic structure of all files. In order to form the bit map, we have a series of numbers that are registered within the grid of the image file. Another factor that is common to files is the numerical method for defining the value of the light captured. Although not in the originally captured image file, all other files must handle the raw or interpolated color generated from the illumination information in the captured file. Finally, a part of the file will be an **algorithm** that converts the data for future use.

Of these parts, the major difference between files is found in the algorithm for each file type. The algorithm consists of the standards, steps, and actions required to convert the numerical data into an image. Some of these components are universal, such as color and a **binary** numbering system (as discussed in Chapter 5). The non-universal parts are the image structure, bit order, compression, and applicability. All of these non-universal portions of the file define the **file format**.

Bit Depth and Color

In Chapter 5, we discussed how colors are generated. A 24-bit color format uses 8 bits (256 distinct numbers) of value information for each of the three primary color channels (red, green, and blue, or RGB) and mixes them to form the image color.

Binary In a binary numbering system (base two), only two numbers make up all the values. Such a numbering system works exceptionally well in the computer environment, as the number 0 can apply to the power being off while the number 1 represents a charge. This base unit—0 or 1—is a *bit*.

File format The file format contains instructions on how to encode, save, and extract data in a file.

This means that 3 bytes of image information will be generated for each pixel at a 24-bit depth. The World Wide Web uses an 8-bit format having 256 separate colors with no other mixtures possible. An adaptive pallet can be applied to an 8-bit image that allows color in the image file to better communicate the photographer's wishes or perceptions. Both capture and saving use up to 48-bit file formats, or up to 16 bits (2 bytes) per channel.

Beyond the bit depth of the file, another color consideration is the color metrics used to coordinate color. Of these, the **Commission Internationale de L'Éclairage (CIE, International Color Commission)** L.a.b. color space is the most commonly used. This system defines the color by its value and either the "a" axis (red–green) or "b" (yellow–blue). Most files use this type of three-dimensional color space. In some files, embedded color preferences are also recorded and can be used to reconstruct the image as it is opened or output.

Many of today's file formats include information about the image that is not part of the image's pixel structure, referred to as the **metadata**. This information is important for tracing the history of the image (such as when the image was made or modified) or for control of the image function, such as an embedded color space or correction.

Commission Internationale de L'Éclairage (CIE) The color measuring and numbering system created by the CIE is based on human perception and is heavily used in digital imaging.

Metadata Metadata are information attached or stored within a file format that is not part of the image.

Figure 8-1 The CIE L.a.b. color space is a model that has hues arranged around the equator. L is the luminance, with the top being white. The (a) axis is hues of red–green, and the (b) axis is hues of blue–yellow.

File Size and Detail

A common misconception is that the count of pixels on the sensor is the same as the files that the sensor creates. There are two ways that files and megapixel counts differ. First is the way color is interpolated. As just mentioned, the file size will vary because of bit depth. Generally, a 24-bit color generates 3 bytes of color data at each pixel. This means that a file size will be three times the number of bytes as there are pixels

on the sensors. Also, file sizes do not match the sensor size due to **resampling** and enlargement of the pixel count that was originally captured. The file becomes larger because of an interpolation algorithm that adds pixels and then adjusts image quality for better appearance. One of the most common methods for this type of file expansion uses a mathematical concept called *bicubic resampling* and then edge enhancement. This resampling technique is applied to the captured file prior to the file being used or saved. While this type of enlargement creates larger files, it does not add detail to the image.

Bit Order

The bit order used with each byte in the image file has ramifications on how the file will be decoded and transmitted. Having a compatible bit order within the files is particularly important in relation to color bit-mapped images.

Compression

The type of compression used in the file is another variable. Compression reduces the file size by applying mathematical operations on the data within the file. Many camera systems compress the capture file before exporting the image for other uses, but in these cases the computer or camera system program is determining the important and unimportant data in the image and discarding or rewriting the data. The mathematics of the compression defines the two basic types of compression: **lossless** and **lossy**.

Lossless compression reduces the size of a file without the loss of data. This compression uses a method that stores pixels as the one piece of information when the same color value (R, G, B digital number) is present in adjacent pixels. Mathemati-

cally, this allows for a pure function, without any differences in the data before compression and after decompression. Because the compression method stores sameness in one locator for linearly aligned pixels it is often referred to as *pixel packing* or *run-length encoding*. While there is no loss of data when decompressing with lossless compression, the gain from this model achieves a maximum compression ratio of about 2:1, or a 50% reduction in file size.

The lossy method of compression has great file reduction potential. Lossy systems can reduce files by as much as a 300:1 compression ratio; that is, it can bring a file size down to about 3% of its original size. This model takes neighboring pixels of similar data and saves them as the same value in one group of data. As a simplified example, it might treat the color of a red apple and a red fire engine as the same color. The critical issue for lossy compression is how much loss is acceptable at decompression, based on the final file size.

Lossy compression utilizes a basic understanding that human perception will not notice small color changes when files are decompressed. This is taken a step further with a process called *visually lossless compression*. Though not heavily used, in visually lossless compression the algorithm discards a large portion of color information in a regular pattern while retaining the tonal information at each pixel.

Regardless of the type of compression, the effect of the compression will not be seen when the file is being compressed; it will be apparent only after decompression takes place and the file is opened. One must consider, then, how much image quality and data can be sacrificed for a reduction in file size.

File Types

The most important consideration for file choice is the application chosen for the image. The following list of file types is not complete but does provide a look at some

Purely Abstract #6. © Ian Macdonald-Smith.

of the common types and how they are used. All of these files are cross-platform compatible.

RAW Files

RAW files are closest to the actually captured file. This file format records the filtered color at each pixel captured and quantized in the pixel's filter color. A RAW file does not interpolate the color from adjacent pixels to form an image. The RAW format file records the light captured at each photosite in its filtered color at the number of bits directly from the sensor. The file cannot be viewed as an image without software to interpolate the color information and produce the expected image.

RAW files are different for various capture systems because each system has proprietary image processing, and the file extensions will vary. For Nikon systems, the extension is .nef; for Canon, .crw; for Kodak, eir; and for Leaf, .mos (for Mosaic), to name only a few of the file extensions in use. These files are not interchangeable and cannot be viewed through a different camera's converter or viewer. For this reason, a plug-in is required for computer viewing or manipulation. This plug-in may be proprietary or a more universal software tool, such as a Photoshop® plug-in. At the time of this writing, interpolation of an image tends to be better using the camera manufacturer's converters rather than through universal conversions found in post-capture software.

There are three major advantages to the RAW file type. First, it is able to handle large data capture and is not constrained by the need to interpolate color. Second, future software improvements can be applied to images stored earlier as RAW files. Finally, the size of RAW files is smaller than that of interpolated color files. Even though RAW files use no compression, they are smaller when the RAW file is a 16-bit format than an interpolated 8-bit-per-channel file.

TIFF (Tagged Image File Format)

The name of this type of file refers to the metadata (i.e., the tag) written into the file. This portion of the file provides the user with information about what the image is and how to reconstruct it when it is opened or used. TIFF files have an extension of .tif. For many camera systems, TIFF files are the highest level of interpolated color image files available. For many years, the TIFF format has had wide acceptance in the graphics and printing industries. The tags on the TIFF files make them exceptionally useful when working with cross-platforms and in multiple software applications. This extends to being able to save in multiple software applications, including the ability to save channels and layers. Within most software applications, TIFF files open or save more slowly than file formats that are resident to that program. TIFF files can be stored as compressed or uncompressed files and will handle large bit depth (12 or 16 bits per channel). They may be compressed by lossy or lossless compression, although lossless is more commonly used. Lempel–Ziv–Welch (LZW) compression is a lossless compression used in the Macintosh® platform; ZIP compression is used in both Macintosh and PC platforms. These compressions are particularly effective when there are large areas of the same color. TIFF formats supports the use of layers in programs such as Photoshop®.

PSD (Photoshop® Document)

A Photoshop® document is a vehicle developed for use with a specific piece of software. Although the .psd file type was created for the Photoshop® program, it is compatible with many other types of software. This allows these other applications to use a file that has been saved as a Photoshop® document, as it can be opened and manip-

ulated to varying degrees. Unlike other file types mentioned in this chapter that were designed as methods to save data, the Photoshop® document type of file was intended as a processing-based vehicle.

JPEG (Joint Photographic Experts Group)

One of the most common file formats is JPEG, with the file extension .jpg. This file format is common on many cameras and on the World Wide Web. While the format can be lossless, it is most commonly used as a lossy compression file. The compression in JPEG can reduce the image files to very small sizes. It is important to know that every time a file is saved in JPEG, compression is applied to the file. This means that if a file is opened and then saved without any other change, the file will be compressed again. Thus multiple file saving in JPEG format continuously compresses the file with lossy compression.

The potentially small sizes give Web users the ability to move files quickly, and consumer-level imagers can store large numbers of images on any medium. The JPEG file algorithm varies the amount of color or value information that can be discarded. This can be done by switching or lowering the bit depth of the file. While the file format supports 24-bit color, it can also use 8-bit or lower color to achieve the smallest optimal size.

The Joint Photographic Experts Group is developing a new file format referred to as JPEG 2000. This file format will have several important features, including security potentials, prepress and fax document compatibility, use of motion imaging files, and Web language applications. JPEG2000 is based on wavelet technology that divides the data into frequency components equivalent in scale to the data.

Untitled. © Tim Meyer 2003.

GIF (Graphics Interchange Format)

Developed by Compuserve® in the 1980s for use on the World Wide Web, this file format, with the extension .gif, allows efficient movement of files. Using an extremely lossy compression based on 8-bit color (a total of 256 distinct colors), it accomplishes the greatest reduction of file size. Because of the color format and compression used in GIF files, decompressed images will often exhibit banding or posterization of the tones and colors within the image. This format is useful for putting images on the World Wide Web but was not designed as a primary image file format.

EPS (Encapsulated Post Script)

Using the extension .eps, this file is designed for use in the graphic arts field. The format handles both bit maps and vector graphics. The vector graphics are used to support PostScript®, a format designed for various aspects of the printing industry, including typography and certain graphics applications. When the data are presented in a vector graphic form, the number of pixels does not confine the scale of the output, as pixels are not found in a vector graphic file. This function in EPS allows resizing without loss of information or pixelization of type and graphics. EPS also allows embedded bit maps, thus supporting the use of digital images in the files. The EPS files are used extensively in prepress applications.

PDF (Personal Document Files)

Personal document files, with an extension of .pdf, were developed to use the features common in desktop graphics and imaging that use embedded fonts and images. These

Salt Lake. © Ike Lea, Lansing Community College.

files are created by Adobe Acrobat®, which uses a unique method to send files to a printer; its raster image processor (RIP) simplifies graphic and color output to produce a file that can be accessed by a variety of users across several platforms.

Summary

- The four types of files used in digital imaging are capture, working, archiving, and output/transfer files.
- Features common to all types of files include the basic bit map structure, binary numbering system, and algorithm used to write and store the image.
- File size is influenced by the pixel count of the sensor, color bit depth, and size interpolation.
- Color varies in files and is important in file size and compression.
- Three types of compression are used in image files: lossless, lossy, and visually lossless.
- The many types of files include RAW, TIFF, PSD, JPEG, GIF, EPS, and PDF. Each has its own benefits and functions within digital imaging.

Glossary of Terms

Binary In a binary numbering system (base two), only two numbers make up all the values. Such a numbering system works exceptionally well in the computer environment, as the number 0 can apply to the power being off while the number 1 represents a charge. This base unit—0 or 1—is a *bit*.

Commission Internationale de L'Éclairage (CIE) The color measuring and numbering system created by the CIE is based on human perception and is heavily used in digital imaging.

File format The file format contains instructions on how to encode, save, and extract data in a file.

Lossless compression If a file format can compress encoded data and then decompress the information in the data without degradation, then it is lossless; this is a reversible compression concept.

Lossy Lossy is any type of file compression that shows a loss of data when opened after saving.

Metadata Metadata are information attached or stored within a file format that is not part of the image.

Resampling Resampling is changing the image file to increase or decrease the number of pixels that are in an image. When a file is permanently reduced in size, data are lost; however, if the file is increased in size, no new detail is added to the image.

Six Pack. © hansenphoto.com.

Chapter 9 Overview

Chapter 7 discussed neutral balance in the workflow, and this chapter examines why we need to balance for the light's spectral bias, where in the process we can apply balancing, and how balancing is accomplished. These corrections can be made within the capture workflow, using post-capture software applications, or via output control.

Light Balancing

Photography, whether with conventional film or digital imagining, is about capturing light. The term *photography* is derived from the Greek words for light and writing, thus reflecting the importance of understanding light to make good images. As explained in Chapter 7, a major problem in balancing a picture so that the colors are captured correctly is the way our perceptual system works. The human perceptual system holds constant as much of the learned world as possible. This constancy has a great effect on our perception of color, as well as our ability to neutralize light. To

understand how to better balance images, it is helpful to examine how light functions. Most important is the spectral makeup of light.

Spectral Composition and Balancing

Spectral energy distribution (SED) This is a measure of how the energy of a particular light is distributed. When graphed as a spectral distribution curve, the height of the graph represents the amount of energy at any point in the spectrum.

The spectral composition can be defined as the **spectral energy distribution (SED)**. This is a determination of how much of the power of the energy comes from what part of the electromagnetic spectrum. The amount of energy at any wavelength of the spectrum is measured as its relative energy output. When this value is graphed compared to the wavelength a spectral distribution curve results. This curve reveals the color bias of the light.

The most commonly used light for photography is the sun. When we look at midday sunlight, often referred to as *skylight*, we can see how the energy is distributed over the visual spectrum. While the light's energy is greatest at the blue end of the spectrum, relatively high values can be found in all areas of the spectrum except the violet portion. If the light is purely neutral, the curve would be horizontal with even values at all portions of the spectrum; however, because relatively strong energies exist across the spectrum we will see the light as neutral or white light.

Because of the digital sensor's weakness at the short wavelengths (violet), the higher blue spectral energies in the light have less effect and a natural balancing effect. However, to totally balance the light a small adjustment must be made to the higher end of the spectral energies (red). As the sun moves across the sky, the atmosphere differentially bends the light and changes its color bias from red at dawn and dusk to the more neutral midday color of light. Neutral balancing can remove the color bias from images made at any time of day, but it may be desirable to use a preset light balance to allow the warmth of the sun to be seen in an image at sunrise or sunset.

Figure 9-1 SED of sunlight.

While midday light is not noticeably biased to the blue end of the spectrum, northern light or clear sky open shade is noticeably blue. This is clearly demonstrated with an SED curve. The SED curve for northern light shows that the shorter wavelengths comprise the majority of the strength of the light, with a smaller effect from the higher end of the visible spectrum. In this type of light, the response to blue must be reduced in comparison to the red end of the spectrum. Northern light can be balanced with over-the-lens warming filters, which make it appear as though the warmer end of the spectrum is strengthened; actually, it remains the same but is more effective compared to other areas of the SED. Filtering is not as accurate as electronic balancing, however.

Figure 9-2 SED for northern skylight.

Another type of light commonly used for digital photography is the electronic flash (strobe). While conventional photography uses the same film balance for both daylight and electronic flash, with digital imaging much finer adjustment of the color balance can be accomplished. The SED curve shows that this type of light is similar to daylight but with a slight increase in energy in the blue–green area of the spectrum. Electronic balancing depresses these blue–green energies. While not shown in the spectral distribution curve, an electronic flash puts out high levels of **ultraviolet (UV)** energy. Many flash heads are coated with a UV filter that is effective for film capture, but because of the inability of camera sensors to effectively capture UV this is not required for digital capture.

Ultraviolet energy (UV) These are wavelengths shorter than visible violet light but longer than x-rays.

Studio lighting may require continuous light sources. The most common continuous light sources are quartz halogen lights. These use a tungsten filament that heats up to generate the light. The SED curve for these incandescent lights is the reverse of that for northern light. The color light from such hot lights is strongly biased toward the red end of the spectrum. Damping the energies at the red end of the spectrum and visually elevating the blue end correct for the redness of the light.

While not recommended for photographic purposes, occasionally it may be necessary to photograph under fluorescent light. Fluorescent lights generate light by

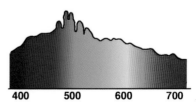

Figure 9-3 SED for the light from an electronic flash.

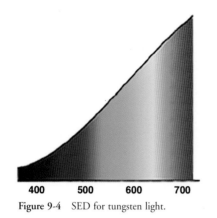

Figure 9-4 SED for tungsten light.

passing electricity through a mercury vapor to produce a large amount of ultraviolet energy. The UV light interacts with phosphors on the inside of the tube which generate the majority of the light. When looking at the SED curve for fluorescent light, we can see that the line spikes from the energized mercury vapor and the light of the phosphors produces a continuous curve. Fluorescent light has a noticeable blue–green cast that must be reduced for neutral balancing.

Another type of light used for photographic applications is the metal halide lamp. Most commonly referred to as *HMI* (Hg [mercury], medium arc, iodine) *lamps* and also known as *metallic halide lamps*, these lights are discharge lamps made by adding metal oxides to a small mercury lamp. The addition of the color from the metal oxides' light discharge that is seen in the closely spaced lines, the SED curve shows a rather even pattern that is biased toward the red within the strong mercury spectrum. The closeness of the lines in the SED created by the metal oxides shows a light source that acts as a continuous source.

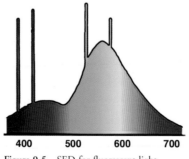

Figure 9-5 SED for fluorescent light.

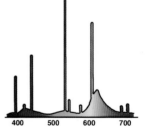

Figure 9-6 SED for light from HMI lighting.

Post-Capture Correction

Post-capture operations used to balance neutrality and tonalities in images can be applied to any image format or bit depth; however, there are advantages to using the largest bit depth in the RAW file format if available. If post-capture correction is performed before interpolation at its maximum bit depth, the final image will have fewer artifacts caused by the adjustments. Neutral balancing applies a global correction to the capture of a digital image; however, adjustments to the image may be required to maximize the captured image.

As we begin this discussion of post-capture correction, an important warning must be made: Whenever a digital file is modified in any way, data are lost. For this reason, the originally captured, uncompressed file with the highest bit depth must be saved. Because there is no difference in quality between the original and copies of that original, it is the copies that should be manipulated or altered. The RAW file option is the best choice for archiving the original file.

A key to understanding how images are balanced is the histogram for the image. The histogram is a graph of the number of pixels at each of the digital numbers represented in the image. On the horizontal axis are the digital numbers. In a 24-bit color image (8 bits per channel), the left end of the histogram represents the digital number 0, and the right end represents a value of 255. The vertical axis of the histogram represents the relative number of pixels at a given digital number. While the histogram could use a numerical scale to give an exact count of the pixels at any given digital number, this would result in an unwieldy graph for most uses; therefore, the histogram only gives a proportional representation of these numbers to keep the graph in a reasonable form.

Color images have three histograms, one each for the primary colors of light: red, green, and blue (RGB). An overall histogram is a composite of the individual color histograms; however, when viewing a histogram for a RAW file, all three graphs

Texas Trees. © Kathryn Watts-Martinez.

are shown. In the three-graph version, each channel is displayed on the same graph. Neutral is created where all three colors overlap, and the secondary colors (cyan, magenta, and yellow) are produced where two of the primary colors overlap. Even when the image is interpolated, the three channels can be separated based on the portion of each color represented in each pixel.

As an example, if we look at the histogram for a grayscale gradient, we can see a continuous form with no gaps. Now, if we make an adjustment, such as changing the contrast, we notice that the black and white levels stay at the extremes but now there are lines in the histogram. These white lines, known as *combing*, show where there are no data.

By accepting a certain loss of data, we can process an image to correct a deficiency acquired during the capture process. The two major ways in which image files can be changed are **point processes** and **transforms**. A point process is an adjustment that performs the same arithmetic change to every pixel selected for change. Transforms are complicated changes in the image structure such as rotating or warping. Most adjustments are point processes, and filters are transforms. When using image software, point processes, including most adjustments, can be used with 16-bit channels. Most transforms, because of the higher levels of calculations required, are available with only 8-bit-per-channel images.

Point processes Point processes are the simplest computer adjustments; they perform the same operation on every pixel in the image or selected area.

Transforms These are complicated mathematical modifications of the image structure. The computer uses higher-level algorithms to change the image, often one point at a time. Applications such as rotating or warping and most software filters are transforms.

Figure 9-7 The histogram on the left shows the output before adjustment; the histogram on the right shows "combing" after adjustment.

Shift and Stretch

As an example of a point process, if we wanted to brighten an image by 20% we could add a 52 numerical value shift to all pixels. Pure black (0:0:0) would still be dark but brighter in tone (52:52:52). At the same time, a middle gray tone (127:127:127) would become lighter (179:179:179). At the high end of the scale, the values would become compressed. The spikes in the histogram of this shifted tonal scale show the 20% compression. While we get spikes when we shift the output values to brighten the image, combing results if we stretch the levels to move a lighter tone to become black and at the same time maintain the white value. For a 20% value stretch, suppose we move the point with a value of 52 to a value of 0, or the black point. This makes a change for 203 tones in our scale to become an output of 0–255. Here, we can see the 52 steps of stretch in the 52 white lines in the histogram.

These two point process examples were on a grayscale, but the same operations can be performed on individual color channels to shift the color balance. We can add small amounts of color to each of the red, green, and blue channels and in this way correct the color bias in a digital image. The image shown here has a blue bias because the image was shot late at night. A sample of a location on a known neutral wall shows values of 181 for red, 182 for green, and 208 for blue, indicating a blue bias of 26. If the effect of the blue channel can be reduce by 26, then the image will be

Figure 9-8 The difference in the histograms shows the effect of shifting the black point.

Figure 9-9 The white lines show the stretching to move endpoints of the grayscale.

Figure 9-10 The image on the left shows the blue cast from making an exposure after sunset. The right image shows the image after correcting the image in its three channels.

corrected for the neutral tone. To apply this correction blue can be reduced or red and green can be increased. As an overall point process, these global changes are applied to each pixel equally.

The simplest adjustment tool is **levels**, which are linear processes allowing shifts in or stretching of the image's tonal information in individual channels or as an overall adjustment. These simple adjustments also include brightness, hue/saturation, and color balance. When using a RAW file, this operation can be performed before the image is interpolated and exported for use in other portions of the digital workflow. This is often done to allow shadow detail to be opened up.

More complex and more useful are **curves**, which use a graphical approach to analyze an image; that is, changing the shape of the curve adjusts the color. While levels are useful, curves give us the ability to handle specific parts of the tonal

Levels Levels are used to modify the distribution of tones in an image in relation to output by changing the white point, black point, and gamma (slope of the curve).

Curves Curves are graphs in imaging software that show how inputs are related to outputs. In most software packages, the curves can be changed to alter the look of the image.

Fire6.AMR. © by Anacleto Rapping—Los Angeles Times.

range or color channel. This is particularly important in color balancing for color management.

Curves and Color Balance

Curves are graphic representations of the input tones versus the output tones. The curve is a graph in its default mode that shows a straight line representing the value of input and the value? it will be outputted. A straight line at a 45° angle indicates that any digital number in the image will have a similar number as the output. As the digital number rises, so does the output value. As with a silver halide curve, we describe the top as white in digital or transparency film or as maximum density with negative films, the low point as black for digital and transparency films and the lowest exposure for negative film, and the slope as gamma. If the curve is changed, then the digital output values change. If the bottom scale is reversed by clicking the arrows on the lower scale, the image output becomes negative.

Figure 9-11 Curves dialog box.

There are three tools for using the curve: (1) change the shape of the curve by selecting a point on the curve and moving it, (2) draw the desired curve, or (3) select points in the image and set these selected points into the curve as the white, mid-tone, and black points. When the curve shape changes it alters the output for the image. For the default curve, with white output at the top right, if the white point is moved horizontally to the left, then the digital value required to output white will be lower. At the same time, the slope of the curve will become steeper, thus increasing the contrast of the image, as there will now be less difference between white and black in the captured image. When the black point is moved horizontally to the right, the black level is actually captured at a tone lighter than black. In the default curve setup, horizontal moves affect the captured values required to create black and white.

In this curve moving the black point upward will make the output for the lowest exposure lighter than true black. Moving the white point down will add grayness to the captured white. At the same time, either of these movements of the curve's ends lessens the slope and softens the contrast of the image.

By selecting a point on the curve other than at the ends, the curve is bent as the selected point is moved. Selecting multiple points allows for changes in various areas of the curve. If the curve is rounded toward horizontal, the output tones are compressed in relation to the captured values. Rounding the curve toward vertical increases output separations between captured values. While these changes can be accomplished by deforming the existing curve, it can also be drawn and then smoothed out.

The selection tool is used to select points in the image and set the input/output levels on the curve for the selected locations. If a point is selected as black, then that captured level will be set as black output. The same is true for the white and mid-tone selections. The white and black selections set the end points of the curve, and the mid-tone selector changes the shape of the curve. The shape change bows the curve, increasing or decreasing the slope and the contrast of the image above and below the selection point.

This operation can be performed for red, green, blue (RGB); cyan, magenta, yellow, and black (CMYK); or specific color channels. When working with either RGB or CMYK alone, the color bias is not changed, but using separate color channels allows for color correction. To do this, the curve dialog selector is changed to one of the color channels, and the same actions are taken for each of the channels.

The image shown here was taken on location without standard lighting equipment; thus, after processing the film had a red bias. To correct the image, the curves were changed by selecting the black, white, and mid-tone points for each of the three color channels. The dots on the first image show the three selected points that were used as the black, white, and neutral places in the image and put into the each of the

Lunaboard. © J. Seeley.

Figure 9-12, Figure 9-13, and Figure 9-14
The first figure shows the image with the
curve having black input at the right and
black output to the top. The second figure
shows an increase in contrast gained by
moving the black point (top) and the white
point (bottom) toward the center of the
graph; this has simply changed the minimum
input that will be output as white and the
maximum digital number that will be
represented as black. This increases the
contrast but causes both highlight and
shadow details to be lost. The third picture
reflects an increase in the contrast for the
middle of the curve and a decrease in the
contrast for both highlight and shadow
details. This has maintained details while
changing the contrast for the image.

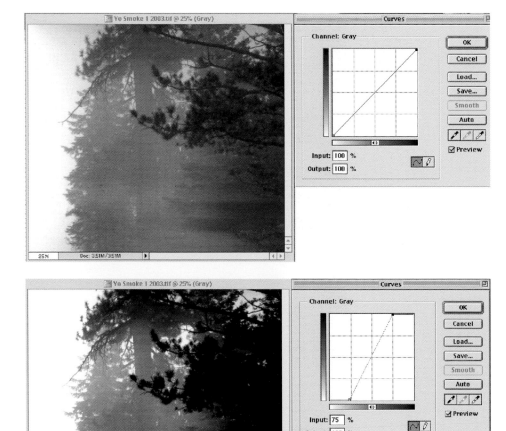

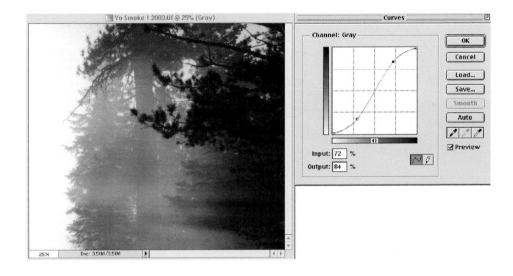

Figure 9-14 *Continued*

three curves. As selections were made for each point in each channel the curve changed. The end result, after combining the three curves, was an RGB corrected image. The curves indicate the changes in each channel.

Many feel that the best color correction can be achieved by using the subtractive CMYK colors instead of correcting for RGB. In order to work in CMYK, the file must be converted from RGB (as captured) to CMYK, which requires another color interpolation. There are two reasons for doing so. First, only CMYK gives a true black–white value scale; in RGB, the curves generate a composite black. The second reason has to do with ultimate use of the image. Most images are printed, and the CMYK family of inks and dyes are used to print images. Some professionals believe using curves in these four channels and adjusting these curves provides better agreement between the image file and the printed output.

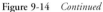

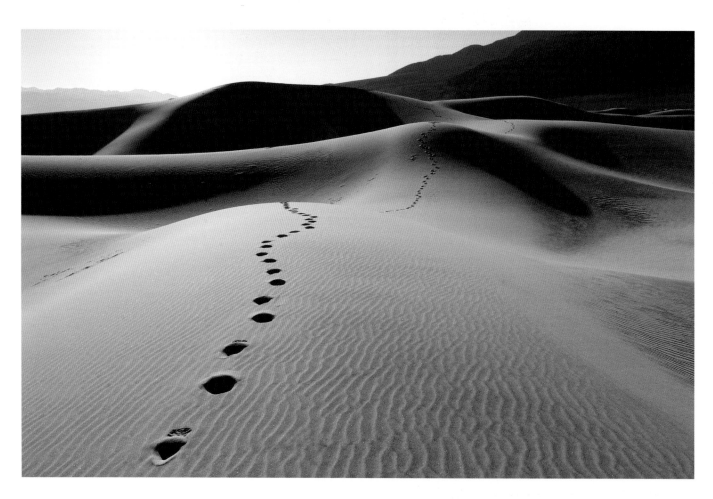

Footprints, Death Valley. © 2004 Terry Abrams.

Figure 9-15 The image on the left shows the original image and the points used to adjust the curves to achieve the final image.

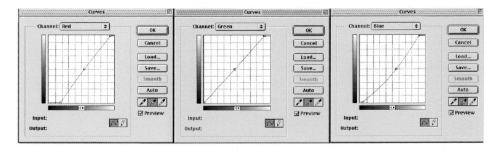

Figure 9-16 Three curves used to adjust the image in Figure 9-13. The lower point on each curve shows the adjusted black level, the top point shows the white placement, and the midpoint shapes the curve to adjust for neutrality.

Summary

- The spectral energy distribution (SED) shows the amount of light energy at any given wavelength and reveals color bias.

- The SED is the basis for capture-based color balancing.

- Corrections are possible after the image has been made.

- When a digital file is modified, data are lost; therefore, always work on a duplicate file and archive the original capture, preferably as a RAW file.

Natasha. © Joyce Wilson.

- Global adjustments are normally point processes that can process 16-bit-per-channel pixels; transforms involve higher-level mathematical functions and can be applied to only 8-bit-per-channel pixels.

- Levels can shift or stretch the tonal range or output range for the total image or individual color channels.

- Curves can adjust the contrast and color balance for the total image or individual channels.

- Some professionals believe that the use of CMYK rather than RGB is beneficial if the final product will be printed.

Glossary of Terms

Curves Curves are graphs in imaging software that show how inputs are related to outputs. In most software packages, the curves can be changed to alter the look of the image.

Levels Levels are used to modify the distribution of tones in an image in relation to output by changing the white point, black point, and gamma (slope of the curve).

Point processes Point processes are the simplest computer adjustments; they perform the same operation on every pixel in the image or selected area.

Spectral energy distribution (SED) This is a measure of how the energy of a particular light is distributed. When graphed as a spectral distribution curve, the height of the graph represents the amount of energy at any point in the spectrum.

Transforms These are complicated mathematical modifications of the image structure. The computer uses higher-level algorithms to change the image, often one point at a time. Applications such as rotating or warping and most software filters are transforms.

Ultraviolet energy (UV) These are wavelengths shorter than visible violet light but longer than x-rays.

Craig Duggan © Hedrich Blessing 2000.
"Panorama from One Wacker Drive" by Craig Duggan. This panorama was captured by a large-format view camera, which allowed the use of a wide-angle lens with a vertical format to extend the angle of view to include most of the high buildings near the camera location and the river and street level. Because a very wide-angle lens and perspective control were used, film was required in this case. If a digital scan back had been used, image aberrations would have been caused by the scanning, movement of light, and environmental events. Also, with the wide angle of view, exposure falloff would have occurred at the extremes of the image frame. The ten exposures seen in the lower image were used as hybrid media to create the 360° panorama.

Chapter 10 Overview

A hybrid approach that combines film and digital capture opens up new imaging potentials that are not possible with digital capture alone. This chapter discusses the benefits and shortcomings of using film capture with digital output and provides a direct comparison of both digital capture and hybrid paths to a digital image.

Choosing Hybrid Digital Photography

Digital capture is becoming the dominant form of photography but is not the "end all." The existence of hybrid imaging admits that digital imaging has not achieved superiority in all areas of photographic capture. With this in mind, rejection of previously learned skills or abandonment of acquired equipment is counterproductive; however, as we rush to the new, we need to realize that our goal is in making the best choice.

As we transition from silver-halide-based photography to an electronic-enabled future, let us step back to look at the convergence of these processes. Today, neither

digital capture nor hybrid digital photography is superior in all situations; in the imaging world, each technique maintains its usefulness for particular applications and offers certain advantages within these applications.

Sometimes hybrid imaging is simply the most practical choice. From an economics point of view, it can be argued that the lower costs offered by hybrid imaging make it the superior approach; however, at the 35-mm size, hybrid imaging does not always offer a significant cost advantage over digital imaging. So, why choose hybrid imaging? Using film as the capture medium and then converting to digital images provides the photographer with ways to overcome some of the shortcomings of digital capture, and film-based capture also has some built-in advantages that are not obvious when viewing the simplest model of digital imaging alone.

Sensor Size Versus Film

A major point with regard to digital imaging for commercial/professional photography is a comparison of the resolution of digitally captured images to that of film. Doing the math, we find that color film has more than 10 million dye locations per square inch; therefore, a 35-mm negative has more than 15 million locations with color information within the negative image. A 6-cm-square image has over 50 million color locations, and one that is 4×5 has over 200 million color locations. If each color location represents one of the three primary colors used to create a digital image, then the equivalent file size of a 35-mm film image would be greater than 15 megabytes. Today, many cameras have sensors with well over 5 million pixel sites. With interpolation, a 5-million-pixel (3-megabyte/pixel) sensor will generate a 15-megabyte file in 24-bit color, which, it can be argued, is equal to a 35-mm frame.

Let us take another look at this line of reasoning, though. With regard to the issue of interpolation of color, the colors were not actually recorded at each site of

Birdman—Paris, France. © brentwinebrenner.com.

the sensor; instead, only one-third of the color light was recorded. (Although the Foveon® X3 chip does not have this problem, it has fewer pixel locations.) This logic leads to the conclusion that the real value of a digital image lies not in its color file size but in its pixel count. Some cameras do have area arrays that are greater than 14 megapixels and offer similar detail-gathering abilities compared to film, but most professional 35-mm single-lens reflex (SLR) cameras are in the range of 6 to 11 megapixels. Camera backs are available with area arrays of over 22 megapixels, and some scanning backs can gather more than 100 million locations over long exposures in each of the three scanned colors. Depending on the digital camera, the relation to film for sensors is at or below film's detail gathering ability.

The second issue that arises when comparing digital capture to film is the *fill factor*, which is the percentage of the sensor's surface covered by active receivers. Because of the way sensors are designed, a sizeable amount of the surface is dedicated to the electronics required to make the sensor function and move the image off once the image is captured. These areas contribute no information for image formation. Today, the fill factor for many professional sensors is about 60%. While great improvements have been made in increasing the fill factor, this issue is still important when evaluating the detail-gathering abilities of a sensor. Detail from areas not covered by active areas of the sensor must be ignored, combined, or interpolated.

Another issue is the *sampling rate*, which simply reflects the amount of detail that is captured. As noted earlier in the book, it can be said that a minimum of 2 pixels are required to record a detail that is 1 pixel wide.

When we consider these three issues when comparing pixels to grains of film, it becomes clear that such a comparison is not a simple one. With the exception of some of the newer high-pixel-count sensors available in 35-mm SLR-style cameras, film still provides better detail; therefore, the same quality image is not necessarily

produced when the number of pixel sites on a sensor is equal to the number of grains on film. A better approach is to compare resolution, and film has better resolution compared to most sensors.

Though not dealing directly with sampling, lens dynamics affect overall resolution and depth of focus. Several factors—such as the effects of modulation transfer, sensor site size, and optic requirements of the micro-lenses used in the sensor—limit the minimum f-stop for acceptable output.

Color Interpolation Versus Scanned Color

Color is important in most imaging applications today, and herein lies another problem for digital imaging. With the exception of the Foveon® X3 chip design, sensors use a matrix of filters to capture the color of the image. This matrix is designed such that each pixel has a filter over it. The filters are arranged in alternating red/green or blue/green rows, columns, or diagonals, so half of the sites are filtered green, one-quarter red, and one-quarter blue.

With the matrix of filters the image color is not captured in its hue at each pixel (the sensor site), but as a value of one of the three primary colors. The rest of the color is interpolated by using the color information of adjacent sites. This means that the color accuracy is dependent on sampling combined with the filtration pattern. Artifacts, such as color moiré patterns, can result from inaccuracies inherent to some digital capture systems.

Because most scanners use either tricolor imaging or trilinear sensors, the color information is recorded as combined hues at each site; thus, the color makeup of the image scanned is similar to that of the film or print used. While scanning backs use this type of capture, long exposure times are required to produce the images.

Ballet Cover. © Christopher Gardner.

Spectral Sensitivity

One of the biggest advantages of digital capture is responsible for a deficiency in the technique. Silver halide requires more energy to capture an exposure than does a photodiode, which leads to a differential in the spectral energies effective for exposure of film. Digital capture devices are far more sensitive to infrared energy than film. At the same time, sensors are noticeably inferior to film in the blue and violet spectra, with no sensitivity in ultraviolet spectral areas. This deficiency in acquiring images at the blue end of the spectrum leads to added noise and poor image gathering within this spectral region. Film, however, is more sensitive in these short-wavelength regions.

Electronics

The largest drawback of digital capture is operating systems problems. Today's digital cameras and backs are complex computers that have the same requirements as other computers. The issues of power and fragility override most other issues. The problem of maintaining a power supply is familiar to anyone who has used a digital camera for an extended time. The electronic requirements of these cameras mean that batteries or power packs must be changed regularly. Particularly in adverse weather conditions (hot or cold), the battery power or operating system can be compromised. Further, certain types of digital capture systems require a computer connection, which only compounds problems. This issue cannot be avoided by the using cameras with removable media, as doing so does not remove the dependency on microcircuitry that is both fragile and affected by adverse environmental conditions.

One nuisance that makes using digital capture incompatible with some imaging applications is noise. Noise happens when stray electronic information affects

the sensor sites. This happens naturally with most electronic systems but can be exacerbated by heat. As the length of exposure increases, there is more opportunity for noise to develop. This is a problem because noise is more apparent in dark areas; thus, the long exposures necessary for evening and night photography become problematic.

Storage

For a long time, two issues facing digital capture have been storing and archiving the captured images. Major improvements have been made in removable media, but these storage media are still part of the problem. Returning to the issue of image size, we want the in-camera media to hold our images at their highest resolution. As noted earlier, when an image is modified, in any way, data are lost; thus, the photographer will want to use uncompressed files onboard. If the capture system uses 12 or 16 bits per channel (36- or 48-bit color), the image files can get quite large. For example, a 6-megapixel sensor image captured at 24 bits creates an 18-megabyte TIFF file, while a 48-bit image creates a 36-megabyte TIFF file. Even with a 256-megabyte media card, only seven images can be saved at highest resolution and 16-bit-per-channel color. A related but often overlooked issue is how storage media contribute to the deficiency of digital capture with respect to the write speed of the media. For large files, how quickly they can be moved to the media becomes important.

Beyond how much can be saved on the removable media is the issue of archiving. It would be nice to say that committing an image to a CD or DVD would solve that problem. While these media are far superior to removable media with regard to permanence, the usefulness of the media in the future will be determined by technologies that will replace the CD and DVD. The permanence of CDs and DVDs has not been clearly researched, but with the normal development cycles in electronics

it is highly likely that these two storage media will be replaced in the not too distant future. On the other hand, film images offer a long, useful life with careful storage and can be scanned when needed. Also, film can be evaluated by eye, while digitally captured images must be viewed via electronic equipment.

Another important consideration is how cameras reduce file size with onboard compression. Though such compression is avoidable on most professional cameras, some professionals do use high-pixel-count amateur cameras for which onboard compression is an issue. Regardless of whether or not the compression is used, the array processor affects the color rendition.

Hybrid Digital Imaging

Our discussion of hybrid digital imaging would not be complete without addressing the various problems associated with the technique. The three major drawbacks to hybrid digital imaging can be found in the areas of dynamic range, color gamut, and workflow.

Dynamic Range

The most serious disadvantage of hybrid imaging is the short dynamic range of the film process, particularly for transparency films. While the human perceptual system presents the viewer with a range of 1 million to 1 light acquiring ratio or 20 stops of dynamic range, color transparency film records only a 64:1 range, or about 6 stops. Negative materials (both black and white and color) have a 1000:1 range of about 10 stops for normal processing and printing. While negative materials actually capture a greater dynamic range than just stated, the reason why the dynamic range is

Motorcycle. © Wildcat Studios, Stacy Smith.

shortened with negative films is the way the tones reproduce with normal processes on silver-halide-based papers. Because the film captures much more detail from a scene than can be printed under normal processes, the printing process and procedures are the limiting factors.

A system is only as good as its most limiting part. In the case of negative to print, the restricting dynamic range is that of the printing paper. For negative to digital scan, the limiting factor is usually the scanner's ability. While scanned color negatives offer an expanded dynamic range when compared to silver halide printing, other problems are generated by the color masking layer in color negative film. Because of the way color masking is generated in film, it reduces the overall contrast while adding color to the negative, thus restricting the useable dynamic range. Also, the abilities of a scanner are limited, if not totally eliminated, by the way the film captures light, with compression of highlights and shadow details.

With careful exacting processing and printing, black and white materials can extend this range, but such images do not fit well into the commercial realm and require both exceptional processing and printing. One of the finest Zone System photographers says that he can capture and achieve 16 to 17 stops of dynamic range through to the print. This range is achieved by exposing for massive underdevelopment and printing that includes intensification, dodging, and burning to achieve detail in the shadows and highlights. Digital capture gives 14 to 16 stops of dynamic range, or up to 65,000 : 1.

The abilities of various media to deal with dynamic range become apparent in the highlights and shadows as well as in the contrast when accurately exposed, as can be seen in the curve form for each capture method. The rounded portions of the curves show this compression, and the steepness shows contrast. While film will have a solid black and a clear white, the amount of detail in both highlights and shadows is greater in the digitally captured image than in the normally printed image from film. The contrast in the digital image looks flatter because in film the highlights and

CD Player. © Ralph Masullo.

to some extent shadow details are compressed, while digital capture does not compress throughout its dynamic range. This compression is most noticeable in transparency film because the process compresses both highlights and shadows. In negative to print processing, there is compression of detail in the film and paper in shadow detail; with the paper, at the highlight detail areas of the image.

Color Gamut

Humans can see about 10 to 13 million colors. Digital imaging with 24-bit color defines approximately 17 million colors. While the colors generated in digital imaging are finer definitions and segmentation of the total colors available, because of the way the color is captured through filters, these are not truly different colors but rather different areas of the generalized color space. This is also true of film. Because of the higher contrast of the gathering abilities of film, less color space is defined and thus fewer colors available in film than the human eye can perceive.

Workflow

For many photographers, the time that separates the act of taking an image and its finished state is very important. Hybrid imaging involves two additional steps compared to digital capture. Depending on how they are handled, these extra steps may or may not be a bother to the photographer since service bureaus can process, scan, and color manage images simultaneously. If the photographer produces the scans, then quality issues arise that revolve around color management and cleanliness of the scans. Color management and dealing with any color bias from the film require constant monitoring and control. Also, clean-room technology is required to avoid

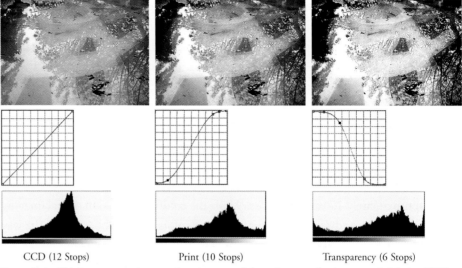

CCD (12 Stops) Print (10 Stops) Transparency (6 Stops)

Figure 10-1 This image comparison examines the captured dynamic range of a charge-coupled device (CCD) (12 stops), negative material with normal processing and printing (10 stops), and transparency material (6 stops). Curves show how the capture media react to exposure. The shapes of the curves indicate compression of light values captured in both highlights and shadows. The steepness of the curves reflects the relative contrast of the images. (These curves have been drawn to provide a comparison and are not necessarily accurate.) These histograms show the distribution of tonal output in relationship to the information captured during exposure and output. The higher the area of the histogram, the more tone is represented at this output level. Note the higher response to highlights and shadows for film, with compression in the transparency film being evident in large amounts at each end of the histogram. The clipping, or loss of detail—indicated by the increases in pixel counts in the highlights of the prints from a negative and transparency film and in the lower digital numbers for transparency film—shows restriction of the dynamic range.

time-consuming retouching. Even with digital correction software, scanning can be problematic.

Comparison

At some point we need to take the deficits and obvious advantages of these techniques into account to compare hybrid digital photography and digital capture. It is no longer an issue of whether or not digital imaging will become a mainstay of commercial/professional imaging but rather which avenues are appropriate for creating these digital images. Comparisons are best split into technology and process issues. From a technology viewpoint, the first concern is resolution, and resolution is best achieved by hybrid digital in all areas that are not 35-mm based or which have certain requirements such as high speed with high resolution. Dynamic range is better with digital capture when compared to normal processing and printing. Color is not particularly relevant to this comparison, as the digital capture and film utilize different color spaces, with only the bias of the photographer determining preference. Film-based systems are more upgradeable. Finally, costs in today's market favor a hybrid approach. From a purely technological standpoint, then, it can be argued that the hybrid approach is preferable to digital imaging alone.

From a process viewpoint, however, the point is easily made for digital capture. With digital capture, processing is far less bother. Hybrid imaging requires physical processing and scanning before arriving at a digital image. For this reason, workflow is simpler for digital capture. Also favoring digital capture are environmental concerns dealing with pollutants and health. The only aspect of processing that favors a hybrid approach is its flexibility. With regard to color, digital capture is preferable for color print processing, while a hybrid approach is preferred for black-and-white

Belize Picture Window. © Kathryn Watts-Martinez.

processing. Overall, from a process standpoint, digital capture would seem to be the better alternative.

Another critical area to consider is that of applications. Different applications require different approaches, and some are not well suited to digital capture. When these particular approaches are called for, this single issue overrides all the others. Large-format, perspective-controlled with depth of focus, long or low-light imaging, and multiple exposures are all instances when a hybrid approach to digital photography is an advantage.

Summary

- Hybrid digital photography uses film to capture the image, and the final digital files are acquired by scanning negatives, transparencies, or prints.

- The sampling rate of sensors, when compared to the ability of film to capture detail, is inferior when using medium- or large-format films.

- There are differences in the spectral sensitivity of film and digital capture. Film is better at capturing short wavelengths, and digital is better for longer wavelengths.

- Several issues arise with regard to the use of digital capture because of its electronic nature, particularly issues of power needs and noise.

- Storage of images remains a concern for those using digital capture. Film serves the purposes of both capture and storage media.

- Digital capture has a larger dynamic range than transparency film and the normal negative to print process. This means that hybrid digital photography is limited because film is not well suited to long ranges of light.

- Workflow is simpler with digital capture than when using film to acquire digital images.

- When comparing hybrid digital photography to digital capture, the critical issue is application, and several applications are better suited to hybrid digital photography.

Glossary of Terms

Numbers in parentheses indicate the pages on which the term appears in the text.

Aberration These are unexpected inaccuracies when lenses create images. They may be edge effects, abnormal color, ect.

Absorption (45) Capturing energy when light strikes a surface and the energy enters the material that does not pass through.

Algorithm (79) Set of mathematical methods, rules, and/or procedures used to solve a problem.

Aliasing (83) Occurs when the shape or attitude of a detail in an image changes faster than an acceptable sampling rate and jagged or step-like artifacts form along the contour of the detail.

Analog-to-digital converter (ADC) (71) Provides a link between the analog world of light capture and the digital world of signal processing by analyzing the incoming analog signal and changing it to digital code.

Anti-Aliasing This is a software application that introduces tonal variations into the image to soften the edges and optically reduce aliasing (the jaggies).

Anti-blooming technology (31) In order to reduce blooming, modern sensors have electrical microcircuits located next to photosites that "drain" excess light-produced charge from the active sites without polluting nearby sites.

Aperture (54) Size of the opening in a lens that allows the light through—larger apertures allow more light to reach the sensor. The aperture is commonly described by the ratio of the f-number.

Apochromatic lenses (51) Compound lenses with higher curvature elements that reduce chromatic aberration. They often have special coatings to further reduce chromatic aberrations.

Array processor (75) Calculates and establishes the colors for each pixel within the digital camera system.

Arrays (35) Arrangements of capture or memory elements in one or more planes.

Autofocus lenses (58) Automatic focus. Automatic focusing lenses use a linear pattern in the sensor to determine focus by movement of lens elements to a point at which the fewest number of sites capture the light.

Banding (76) Occurs when an image has too little color variation; colors tend to become flat and have distinct lines at their borders. Often caused by a limited color space or effects of compression and decompression of the image file.

Basic daylight exposure (BDE) (94) Basic daylight or sunny-day exposure is based on the lighting conditions of a bright, sunny day with the subject in the sunlight. Sometimes this is called the "sunny 16 rule," which states that on a sunny day the exposure will be f16 at a shutter speed of 1/ISO. BDE is an exposure calculated by adding or subtracting f-stops from f16 at a shutter speed of 1/ISO to adjust for various lighting situations.

Batch processing (115) When an image has been adjusted to a desired look, the steps used to make the adjustments can be saved, and the algorithm can be used on succeeding images made under the same conditions. If all the images use this algorithm at one time, then they have been batch processed.

Bayer array (35) A type of filter matrix used in color imaging for many image sensors. The pattern is alternating rows of filters ordered red–green–red–green and green–blue–green–blue. These filters are arranged so that a green site is never next to another green site.

Binary (134) In a binary numbering system (base two), only two numbers make up all the values. Such a numbering system works exceptionally well in the computer environment, as the number 0 can apply to the power being off while the number 1 represents a charge. This base unit—0 or 1—is a *bit*.

Blooming (31) When the energy exposing a photosite is greater than can be held in the potential well, it can migrate to nearby sites and is called "blooming." The effect is of the lightness spreading or streaking from the oversaturated site.

Camera obscura (11) The term *camera obscura* is Latin for "darkened room." The original camera obscura was a darkened room with a hole at one end. An image would be projected through this small hole onto the opposite wall. The image would be inverted. The camera obscura evolved into smaller darkened boxes that used lenses, mirrors, and/or ground glass to aid artists and early photographers.

Capture Capturing, as used in this book, is the act of taking and saving a picture.

Charge-coupled device (CCD) (4, 27) An electronic device made up of light-sensitive sites arranged to process the output in a linear process. The charges recorded and output from each site are proportional to the light intensity at each site.

Chromatic aberrations (49) Caused by lights of different wavelengths focusing at different points. Aberrations can be reduced by the use of multicoatings and compound lens elements.

Circle of confusion (54) Circle of light created when light from a point source is focused on the surface of the sensor. The size is determined by the size of the aperture and the fineness of the focus. If the circle is acceptably small to the viewer, then the image is considered to be in focus.

Clipping (104) When the amount of light exposing the sensor exceeds its ability to record all the energy, the system eliminates these higher energy levels or software eliminates higher digital number values from the image file.

Collimators (61) Lenses used to form light into a column. Similar to a lighthouse beacon, the light has little spread. These are helpful in digital systems as they bring light into the sensor perpendicularly.

Color electronic prepress system (CEPS) or digital prepress (4) The process of using computers or other electronic equipment to prepare plates for the printing press.

Color management Color management is the concept of control that matches the output of the digital process to the input (captured) color. This is one of the most difficult and demanding portions of the digital work flow.

Commission Internationale de L'Éclairage (CIE) (135) The color measuring and numbering system created by the CIE is based on human perception and is heavily used in digital imaging.

Complementary metal oxide semiconductor (CMOS) (27) Computer chips that can be repurposed to act as a sensor. Because they are not specifically a sensor, as in the case of the CCD chip, they can handle many functions of the digital photographic process beyond capturing the light.

Compression (18) A method to reduce a file size by performing mathematical operations on the data file.

Crown glass (49) A type of glass used for making fine optics that consists mostly of lime and silicate of soda or potash, with no lead.

Curves (157) Curves are graphs in imaging software that show how inputs are related to outputs. In most software packages, the curves can be changed to alter the look of the image.

Daguerreotype (4) The first successful photographic process, introduced in 1839, in which an image is exposed directly onto a highly polished silver plate; the image is developed using a vapor of mercury that condenses on the plate to form an amalgam producing an image.

Decibel (dB) (78) Unit of measure expressing the relative difference in power or intensity. It is commonly used to compare two acoustic or electric signals and is equal to ten times the common logarithm of the ratio of the two levels.

Depletion layer (28) Region between the positive and negative semiconductors of the photodiode. This area is free of electrons or positive "holes." Without free or exposed charges, this region is considered depleted.

Diffraction (51) Changes in the direction and intensity of light as the lightwaves pass by an edge or through a small aperture.

Digital imaging (1) Using digital computing devices and processes for producing photographs.

Doping (28) Treating the photosite with an impurity. The dopant causes positive "holes" to be formed that allow the photodiode to collect light.

Dynamic range (78) Measure of the tonal range of light, from brightest to darkest, that an imaging device can capture.

Electromagnetic spectrum (EMS) (28) Range of energy, from long-wavelength radiowaves to extremely short gamma rays, including human observable light. Digital imaging sensors are capable of capturing the visible light and a portion of the infrared energy.

Electronic prepress systems (CEPS) or digital prepress CEPS is the process of using computers or other electronic equipment to prepare publications for the printing press.

Electroplating (33) A manufacturing process used to create sensors (such as CCD and CMOS) that utilizes electronic energy to deposit a layer of metal to specific locations or pathways within the sensor structure.

Exposure (91) A measure of the light captured on the sensor. Exposure is calculated with the equation $H = E \times T$, where H is the exposure, E is illumination (the amount of light), and T indicates time (shutter speed).

File format (134) The file format contains instructions on how to encode, save, and extract data in a file.

Fill factor (33) The ratio of the light-sensitive surface to the overall size of the sensor.

Flare (47) Unwanted reflection within an optical system that is seen as fogging or bright spots on an image.

Four-Thirds standard (4/3rds) (48) A standard for digital camera lenses that allows optimal performance in these digital systems. Sensors do not respond well to light striking at a high angle of incidence, so the Four-Thirds standard uses only the light projected from the lens.

f-stop (54) The ratio for a lens or lens system computed by dividing the effective diameter or aperture by its focal length; used to define lens aperture for exposure calculation.

Gamma adjustment (116) The slope of the curve formed by graphing the input values of the captured image compared to its output values is referred to as gamma. A gamma adjustment is a computer control that changes the relationship between input and output values.

Gate (28) Acts as a control in a digital imaging sensor that allows electrical charge or light energy to have an effect on the operation of the photosite. The gate both allows energy to enter the photodiode and restricts energy flow.

Histogram (114) The histogram is a graph that shows how the light values in the image are distributed. The height of the lines in the histogram represents the number of pixels that are found in the image at any particular value.

Hot mirror (37) Filter used to block infrared light from the sensor that works by reflecting the nonvisible wavelengths and allowing visible light to pass through.

Hyperfocal distance (55) Focusing distance that provides the maximum focus that includes infinity at any given aperture.

Incident meters (96) The dome on an incident meter covers a photocell that evaluates the amount of light transmitted through the dome. This allows a determination of the amount of light falling on the subject.

Indium tin oxide (ITO) (28) A material often used in place of silicon to produce the gates of sensors. ITO tends to provide a better color range because it is optically more transparent than polysilicon.

Input All methods of acquiring an image into the computer, whether with a camera or other data generation methods, is known as input.

ISO (International Standards Organization) (75) Not just an acronym; instead, the name derives from the Greek word *iso*, which means "equal." Photographers are most familiar with ISO ratings of film speeds which are used for sensors.

Levels (157) Levels are used to modify the distribution of tones in an image in relation to output by changing the white point, black point, and gamma (slope of the curve).

Liquid-crystal display (LCD) (12) A display technology often used on digital camera backs and computer monitors.

Lossless compression (136) If a file format can compress encoded data and then decompress the information in the data without degradation, then it is lossless; this is a reversible compression concept.

Lossy (136) Lossy is any type of file compression that shows a loss of data when opened after saving.

Metadata (135) Metadata are information attached or stored within a file format that is not part of the image.

Metal oxide semiconductor (MOS) (27) A family of semiconductors constructed of metal oxides (such as silicon oxides) that are used to construct digital imaging sensors.

Micro-lenses (37) Part of an image sensor above the filters that are used to concentrate light through the filter.

Mosaic or filter matrix (35) A pattern of filters used to gather all colors simultaneously in a color sensor.

Multicoatings (47) Multiple optical enhancing and protective layers used on and between lenses and lens elements.

Noise (40) Unwanted electronic information. Noise is common to all electronic equipment and shows up in a digital image as lighter pixels in otherwise dark-toned areas.

Optics (45) The physical study of light and how it reacts to and with other materials.

Output Output is generally the final use of the image.

Pentaprisms (15) In single-lens reflex (SLR) cameras (both 35-mm and some medium format), pentaprisms allow an image to be viewed through the lens and reflected by a mirror without any reversal of the image.

Perceptual constancy (114) Our perceptual systems find it easier to hold things constant rather than relearn them continually. This means that when we have learned a color we will interpret it consistently regardless of minor fluctuations in the actual color simulation.

Photodiode (28) The portion of a sensor that actually accepts the light, this is a construction of positive and negative portions (*di*, meaning two) that allow the light to be captured. These are also called *sites*.

Photoetching (33) Digital imaging sensors are constructed on an etched surface. This is accomplished by using photographic resist (protection) to protect parts of the surface from chemical cutting. These relief portions on the sensor's base material allow other manufacturing processes and electronic connections to be created.

Photons (30) Electromagnetic energy functions in either a wavelength or particle function, and the "photon" is the designation used when the electromagnetic energy is acting as a particle.

Photosite The part of the sensor that is sensitive to the light is a photosite. It is also called a site or photodiode.

Pixel (37) Smallest part or building block of a digital image. The name is derived from the words "picture" (pix) and "element" (el). Pixels are used to refer to both the individual parts of the image and the number of photosites on a sensor.

Point-and-shoot (12) An amateur camera that is simple to use.

Point processes (155) Point processes are the simplest computer adjustments; they perform the same operation on every pixel in the image or selected area.

Polaroid® dye migration process (4) Process in which dyes that form the print migrate from within the processing film to create an image on the print surface (i.e., "instant print").

Potential well (30) Forms in the silicon base of the sensor when an electrical charge is applied to the photodiode. As the photons of the light are captured, a potential barrier is created that holds the captured energy until it can be discharged.

Profiles (116) Profiles are computer tools that coordinate the input of digital images to their output.

Prosumer (15) A blend of "professional" and "consumer," this term is used to refer to systems that include many professional functions and are intended for use by advanced consumers.

Quantization (72) Process of converting a signal from a set of continuous linear values to a set of related unit values.

Reflection (45) Change of direction of energy as it returns from a surface.

Reflective meters (96) The photocell in a reflective meter reads the light reflected from the subject.

Refraction (45) Physical effect on light; as it passes from one medium to another, it bends.

Resampling (136) Resampling is changing the image file to increase or decrease the number of pixels that are in an image. When a file is permanently reduced in size, data are lost; however, if the file is increased in size, no new detail is added to the image.

Retrofocus lens (58) A lens that works as though it is a longer focal length lens mounted backwards to the camera, thus allowing the lens to have a wider angle of view than normal. It is positioned far enough away from the sensor to allow the mirror in the SLR design to operate without difficulty.

Sampling Sampling refers to the fineness of units captured compared to the detail in the scene.

Silver halide photography (1) Method used for film-based photography (both color and black and white) that utilizes silver halide crystals as the light-capturing element.

Single-lens reflex (SLR) (12) A camera viewing system that uses a mirror at a 45° angle in front of a sensor that projects the image onto a ground glass, thus allowing direct viewing of the image that will be captured.

Site (28) The basic unit of the sensor; it is also called a photosite, photodetector, or pixel.

Spectral energy distribution (SED) (150) This is a measure of how the energy of a particular light is distributed. When graphed as a spectral distribution curve, the height of the graph represents the amount of energy at any point in the spectrum.

Telephoto lenses (57) Lenses that give a magnified view, making distant objects look closer by narrowing the angle of view.

Tethered system (110) A tethered system uses a cable or tether to connect the camera to a computer or external control unit.

Through-the-lens (TTL) meters (96) Through-the-lens meters are reflective meters that read the light in the optic path after the light has passed through the lens.

Transfer (38) Refers to a type of architecture used in the processing of digital images on the sensor. The transfer moves the collected energy rapidly. Transfer types include frame, interline, and frame interline.

Transforms (155) These are complicated mathematical modifications of the image structure. The computer uses higher-level algorithms to change the image, often one point at a time. Applications such as rotating or warping and most software filters are transforms.

Transmission (45) Movement of radiant energy through lenses or other materials.

Tricolor photography (18) Tricolor or trichromatic systems are three-shot capture methods in cameras or scanners that utilize three colors of light (red, green, and blue).

Trilinear arrays (20) Sensors that use three-color filtered arrays over three parallel linear sensors. The simplest configuration has one line each of red, green, and blue filtered sensors.

Ultraviolet energy (UV) (151) These are wavelengths shorter than visible violet light but longer than x-rays.

Under-sampling (83) Occurs when the capture of an image uses fewer sites than the number required to accurately capture a detail.

Wavelengths (48) Distance between successive crests (the high points) of a wave of light—the shorter the wavelength, the greater the refraction. Violet is the shortest visible wavelength; red, the longest.

White balancing Neutral balancing of the light is an important advantage for digital imaging. The light can be balanced with any neutral tone, but is often refrred to as white balance.

photographers' index

197

subject index

Cyan, magenta, yellow, black (CMYK),
balancing curves, 160, 163

D
Daguerreotype, as early process, 4
Dark frame reduction, as exposure factor,
76–77
Dark noise, as exposure factor, 76
Dark-tone metering, and exposure, 101–102
Daylight balance, on location digital workflow,
126
dB, *see* Decibel (dB)
Decibel (dB), as exposure factor, 78
Depletion layer, as photodiode part, 28
Depth of field
overcoming photographic limitations,
129–130
in studio digital workflow, 120
Detail, in image creation, 82–83, 85
Diffraction, and lenses, 51
Digital backs, in professional cameras, 18
Digital imaging overview
and computers, 2
definition, 1
electronic processing, 71–72
vs. film-based photography, 1
and fine artists, 5
image manipulation, 4
image types, 85, 87
and mobile phones, 6
and Moore's law, 2
in photojournalism, 4–5

Photoshop®, 6
and publishing field, 2
simplicity, 4
Digital prepress, *see* Color electronic prepress
system (CEPS)
Digital Versatile Disc (DVD), for photo
storage, 176
Doping, photodiodes, 28
DVD, *see* Digital Versatile Disc (DVD)
Dynamic range
as exposure factor, 78
in hybrid digital imaging, 177, 179, 181

E
Electromagnetic spectrum (EMS)
definition, 28
as exposure factor, 75
Electronic processing, digital images, 71–72
Electronics, and hybrid digital photography,
175–176
Electronic sequencing, in image creation,
67–68
Electronic shutters, in image creation, 68
Electroplating, in sensor manufacture, 33
EMS, *see* Electromagnetic spectrum (EMS)
Encapsulated Post Script (EPS), characteristics,
143
EPS, *see* Encapsulated Post Script (EPS)
Exposure
affecting factors, 75–78
average-value metering, 104
basic daylight exposure, 94–95

calculations, 91–92
dark-tone metering, 101–102
in digital workflow, 113–114
highlight-detail metering, 102, 104
and ISO, f-stop, shutter speed, 92, 94
light meter types, 95–96, 98–99
on location digital workflow, 126
metering basics, 68, 95–96, 98–99
in studio digital workflow, 121–123
substitution metering, 99–100
tonal placement metering, 100–101

F
File format
definition, 134
EPS, 143
GIF, 143
JPEG, 141
PDF, 143, 145
Photoshop®; Documents, 140–141
TIFF, 140, 176
in workflow, 111–113
Files
bit depth and color, 134–135
bit order, 136
compression, 136–137
overview, 133–134
size and detail, 135–136
size reduction via software, 85
types, 137, 139
Fill factor
definition, 33

sensor size *vs.* film, 172

Film

 vs. digital imaging, 1

 vs. digital resolution, 85

 in hybrid digital imaging, 170, 172–173, 177, 179

Filter matrix, in sensor capture, 35

Filters, and color acquisition, 81

Fine artists, and digital imaging, 5

Flare, in optics, 47

Flash, and spectral composition, 151

Flatbed scanners, sensors, 20, 22

Fluorescent light, and spectral composition, 151–152

Four-Thirds standard (4/3rds), in optics, 48–49

Foveon X3®; chip

 and color acquisition, 82

 for color capture, 36

 color interpolation *vs.* scanned color, 173

 in hybrid digital photography, 172

Frame interline transfer, sensor signal processing, 38

f-stop

 and exposure, 92, 94

 in lens function, 54

 overcoming photographic limitations, 129

Fuji®; SR sensor, photodiode use, 78

G

Gamma adjustment, and neutral tone balancing, 116, 123

Gate, as photodiode part, 28

Gels, in studio digital workflow, 122

GIF, *see* Graphics Interchange Format (GIF)

Graphics Interchange Format (GIF), characteristics, 143

H

Hg, medium arc, iodine lamps, *see* Metallic halide lamps (HMI lamps)

Highlight-detail metering, and exposure, 102, 104

Highlights

 in hybrid digital imaging, 179

 in studio digital workflow, 121

Histograms

 and exposure, 114

 and post-capture correction, 153, 155

HMI lamps, *see* Metallic halide lamps (HMI lamps)

Horizon, on location digital workflow, 126

Hot mirror

 as exposure factor, 76

 in sensors, 37

Hybrid digital photography

 color gamut, 181

 color interpolation *vs.* scanned color, 173

 vs. digital capture, 183, 185

 dynamic range, 177, 179, 181

 electronics, 175–176

 as photography choice, 169–170

sensor size *vs.* film, 170, 172–173

spectral sensitivity, 175

storage, 176–177

workflow, 181, 183

Hyperfocal distance, in lens function, 55

I

Image creation

 capture, 69, 71

 color acquisition, 79, 81–82

 electronic processing, 71–72

 electronic sequencing, 67–68

 exposure factors, 75–78

 overview, 67

 quantization, 72–73, 75

 sampling and detail, 82–83, 85

Incident meters, characteristics, 96

Indium tin oxide (ITO)

 as exposure factor, 75–76

 in optics, 48

 in photodiode gate, 28, 30

Interline transfer, sensor signal processing, 38

International Color Commission, *see* Commission Internationale de L'Éclairage (CIE)

International Standards Organization (ISO), as exposure factor, 75, 92, 94

ISO, *see* International Standards Organization (ISO)

ITO, *see* Indium tin oxide (ITO)

Red, green, blue (RGB)
 balancing curves, 160, 163
 and color acquisition, 79
 and color image histograms, 153
 and neutral tone balancing, 115
 in sensor capture, 35
Reflection
 in light absorption, 48
 in optics, 46–47
Reflective meters, characteristics, 96
Refraction, in optics, 47–49
Resampling, for file expansion, 136
Resolution
 digital *vs.* film images, 85
 in image creation, 82–83
Retrofocus lens, characteristics, 58
RGB, *see* Red, green, blue (RGB)
RIP, *see* Raster image processor (RIP)
Rolling shuttering, definition, 68
Run-length encoding, in files, 137

S
Sampling
 color effects, 85
 in image creation, 82–83
 resampling for file expansion, 136
Sampling rate, sensor size *vs.* film, 172
Scanned color, in hybrid digital photography, 173
Scanners, types, 20, 22
Scanning backs, in professional cameras, 18

Scientific equipment, and digital images, 22
SED, *see* Spectral energy distribution (SED)
Semiconductor, definition, 27
Sensors
 CCD *vs.* CMOS, 40–41
 charge-coupled device, 27–28
 charging, 68
 color acquisition, 79
 color capture, 35
 complementary metal oxide semiconductor, 27–28
 exposure factors, 75–78
 filters, 35–36
 in flatbed scanners, 20, 22
 Foveon X3® chip, 36
 and image capture, 69
 light capture, 28, 30–31
 manufacturing, 31, 33
 metal oxide semiconductors, 27
 and metering, 98–99
 micro-lenses, 37
 monochromatic type, 36–37
 overview, 27
 photodiode component, 28, 30
 and pixels, 37–38
 prominent features, 33, 35
 signal processing architectures, 38
 size, *vs.* film, 172–173
Shadow point, in studio digital workflow, 121
Shadows, in hybrid digital imaging, 179
Shift, as point process, 156–157, 159

Shutters
 electronic, 68
 rolling, 68
Shutter speed
 and exposure, 92, 94
 in lens function, 55
Signal-to-noise ratio, for sensors, 40
Silver halide photography, definition, 1
Single capture, and professional cameras, 16
Single-lens reflex (SLR)
 definition, 12
 and digital workflow, 113
 in hybrid digital photography, 172
 and lens type, 55, 57–58
 viewing system, 14–15
Sites, *see* Photodiodes
Skylight, and spectral composition, 150
SLR, *see* Single-lens reflex (SLR)
Smearing, in digital imaging, 71
Software, *see also* Computers
 for digital prepress, 2
 for file size reduction, 83, 85
 for noise reduction, 78
 and through-the-lens meters, 96
Spectral composition, definition, 150
Spectral energy distribution (SED)
 definition, 150
 and fluorescent light, 151–152
 and HMI lamps, 152
 and midday light, 151
 and strobe light, 151
 and studio lighting, 151